IMAGES
of America

LAKE ZURICH

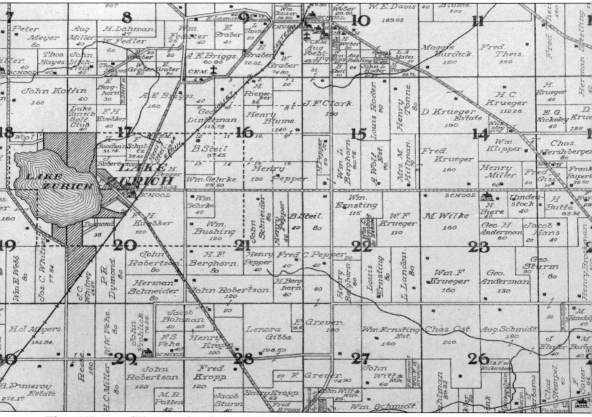

This 1907 map of Ela Township depicts Lake Zurich a little more than a decade after its incorporation in 1896. The map shows the location of points of interest, such as a school and the Lake Zurich Golf Club, as well as major landowners at the time, including John Robertson and Joseph Whitney. (Published by Geo. A. Ogle and Co.)

ON THE COVER: The smiling faces of the swimmers in this postcard are reflective of just how much fun summers in Lake Zurich could be. In the early 1900s, visitors would travel from Chicago to swim, fish, and boat on its waters. Many would also stay in one of the dozens of summer cottages that dotted Lake Zurich's shores. (Courtesy of Janet Paulus.)

IMAGES
of America

LAKE ZURICH

Courtney Flynn

ARCADIA
PUBLISHING

Copyright © 2011 by Courtney Flynn
ISBN 978-0-7385-8305-1

Published by Arcadia Publishing
Charleston, South Carolina

Printed in the United States of America

Library of Congress Control Number: 2010936187

For all general information, please contact Arcadia Publishing:
Telephone 843-853-2070
Fax 843-853-0044
E-mail sales@arcadiapublishing.com
For customer service and orders:
Toll-Free 1-888-313-2665

Visit us on the Internet at www.arcadiapublishing.com

For the people of Lake Zurich, past and present, who inspired this book. And for Tim, Fiona, and Kiefer, who inspire me.

Contents

ACKNOWLEDGMENTS

The glimpses into Lake Zurich's past and the present views of the village included in this book would not have been possible without the combined help of a variety of Lake Zurich area organizations, residents, and businesses.

Nancy Loomis Schroeder of the Ela Historical Society donated her time on countless Saturday mornings to sort through old photographs and fill in historical blanks. The Loomis family has deep roots in the village, and their dedication to preserving Lake Zurich's history is great.

Thanks go to Henry "Hank" Paulus for sharing his photograph collection from the decades he served as Lake Zurich's mayor. Hank's memory and recollection of detail are truly amazing. In addition, Janet Paulus, Hank's daughter-in-law, graciously allowed me access to her extensive collection of Lake Zurich postcards. It was like a neatly organized treasure trove of the village's history.

Bruce Schmidt of the Lake Zurich Alpine Lions Club provided invaluable help by allowing me to thumb through the organization's old photographs and historical logs.

A special thanks to the folks at St. Peter United Church of Christ, St. Francis de Sales Catholic Church, and St. Matthew Lutheran Church, who gave me a peek into their parishes' past.

The Lindgren, Branding, and Keller families also deserve much praise for providing photographs and historical information about their time in Lake Zurich. The Lindgrens bought their first house in the village, and generations of the Branding and Keller families have continued to call Lake Zurich home.

And not to be overlooked was the pleasant and welcoming style of Diana Dretske at the Lake County History Archives. Diana guided my research, pulled postcards from the county's collection, and answered my questions.

My eternal gratitude goes out to my father-in-law, Dr. Flynn, whose photographic skills and unconditional love and support never cease to amaze me.

Lastly, I would like to thank my mother-in-law, Ruth Flynn; my dad, Doug Challos; and my brother, Brett Challos, whose strength and encouragement help guide me. And it is always the memory of my mom, Elaine Challos, that enables me to pursue my dreams without forgetting my past.

INTRODUCTION

For more than a century, Lake Zurich has shared an inseparable bond with the beloved body of water in town that bears its name. In the community's earliest days in the 1800s, farmers used the lake, which spans roughly two-thirds of a mile across, to scoop up drinking water and provide refreshment for their livestock. During the early 1900s, tourists would travel from Chicago and beyond to bathe, boat, and fish on its sparkling waters or relax in one of the many summer cottages along its shores. Rooms could be rented at resorts like the Ficke House, Fred Hoeft's cottages, and Young's Maple Leaf Hotel for less than $2 a day. The lake even played a role in bringing the Palatine, Lake Zurich, and Wauconda Railroad to the area. The railroad was built, in part, because of mounting pressure to find a way to help transport the droves of summer visitors to the water's edge. In the early 1930s, passions over control of the lake grew so heated that a case brought by August Froelich and George and Marguerite Pierce, who owned much of the lake bed, made its way to the Illinois Supreme Court. A 1932 decision by the court allowed the Froelich and Pierce families to restrict lake access and charge usage fees. By 1944, members of the Lake Zurich Lions Club believed the lake was so important that they raised enough funds to buy a majority of the lake bed and some surrounding land to ensure public access. In the early 1980s, the Lake Zurich Property Owners Association was formed to help maintain the lake, establishing various fees and safety and fishing regulations. By 1988, another case involving the lake made its way to the Illinois Supreme Court. In that instance, the court expanded individual lake bed owners' use of the lake. As the years pressed on, many things changed around town, but the lake has continued to remain much as it was in the past, a place that serves as the community's heart.

As important as the lake's role has been in Lake Zurich, the town (founded in 1836 and incorporated in 1896) would not have become what it is without the people who helped shape it. Their local pride has been strong. Schools, parks, and streets were not named after state or national figures, they were named after local leaders whose many achievements are celebrated throughout town. Whether walking along Main Street or strolling near the lake, the presence of the people of Lake Zurich can be felt.

Seth Paine, a businessman from Chicago, was an early settler in Lake Zurich who renamed the lake. First known as Cedar Lake, Paine thought its beauty rivaled the well-known lake in Switzerland and that its name should be reflective of this. He also was responsible for building a place called the Stable of Humanity, which served as meeting hall, school, and, later, a stop on the Underground Railroad. In addition, he started up his own newspaper, the *Lake Zurich Banker*. Old Rand Road was originally known as Paine Street, and Seth Paine Elementary School was named in Paine's honor.

Other early settlers flocked to the area's farmland from New England. By the 1850s, waves of German immigrants began moving to Lake Zurich. At the time, the area's land was predominantly open prairies lined with Native American trails. The town had a few stores and saloons. A creamery was built in the 1880s across from the lake. One of the first immigrants, Henry Seip,

was a businessman who later served as postmaster. Henry Hillman opened the first butcher shop. Frank Scholz was one the first blacksmiths. Herman Prehm ran the first hardware store. Sarah Adams and May Whitney were among the town's first educators in an era when classes took place in one-room schoolhouses and teachers earned about $20 a month. Schools were later named after the two women. Another early settler was John Robertson, who became a major landowner and was fatally shot over a road dispute in the late 1870s. He and Isaac Fox, who donated the land for Ela Town Hall, built some of the first homes near the lake. Main Street was originally known as Robertson Avenue. Fox had a school named after him.

Then there are people such as Fred Blau, Spencer Loomis, and Henry "Hank" Paulus, who also left a lasting mark on Lake Zurich. Blau came to town in 1909 and opened up a barbershop where a shave cost a dime and haircuts only a quarter. Blau went on to become active in the community. As a longtime member of the Lake Zurich Lions Club, Blau helped acquire the land for a park along Main Street that now bears his name. The son of Roy and Josephine Catlow Loomis, Spencer Loomis, was a longtime teacher and principal at May Whitney Elementary School. Another school in town was named after him. Paulus served as mayor of Lake Zurich from 1969 to 1989. Before that, he served as village clerk for a number of years. In addition, Paulus served as trustee for a short time just before becoming mayor. A large park near the lake was named after him.

Over the years, Lake Zurich has witnessed much growth in the number of residents and its development. In the 1930s, roughly 350 people lived in town. By 2003, the population was estimated at more than 19,000. Some residents have called Lake Zurich home for generations. Others have flocked to the area for the quality of its homes and schools. Lake Zurich Community Unit School District 95 enrolled more than 6,000 students in 2010. With the increase of people living in Lake Zurich has come development, which has occurred at a rapid pace in some parts of town. Most of the area's original farmland is now residential subdivisions and commercial buildings. Retail growth along US Route 12 exploded with the arrival of stores like Target, Home Depot, and Starbucks. In 2006, a bypass was constructed, diverting ever-increasing traffic around downtown.

As Lake Zurich continues to evolve and grow, the people in town seem devoted to preserving the village's past while continuing to pump life into its heart, the lake.

One

THE LAKE

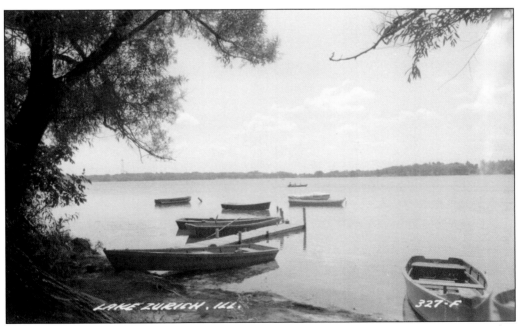

The body of water in town that shares Lake Zurich's name has always been its core. Drawing settlers to the prairies around its shores in the 1800s and later bringing in droves of visitors, sunbathers, and fishermen, for years the lake has had a symbiotic relationship with the village. This postcard shows a peaceful scene of rowboats floating on top of Lake Zurich. (Courtesy of Janet Paulus.)

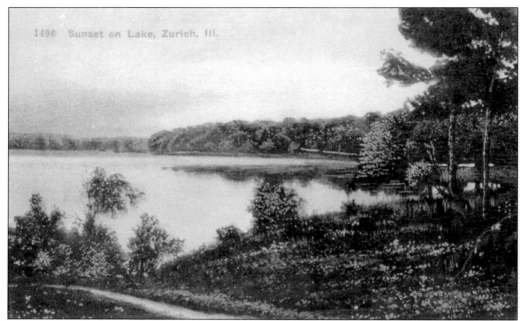

Lake Zurich was originally known as Cedar Lake because of the many cedar trees surrounding it. Seth Paine, a Chicago businessman who settled in Lake Zurich, renamed it in the late 1830s because he thought its beauty resembled the well-known body of water in Switzerland. (Courtesy of Janet Paulus.)

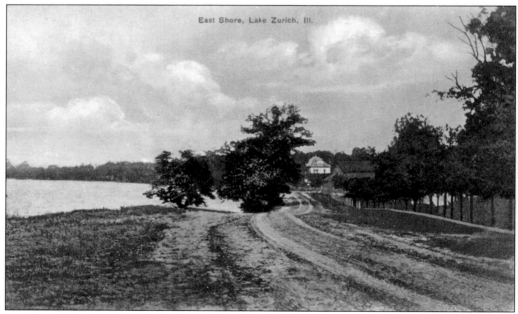

Early settlers who came to Lake Zurich to farm the land used the lake as a source of drinking water for themselves and their livestock. Some of them bought rights to the lake for $1.25 per acre from the Federal Land Office. The entire lake was bought up by 1848. (Courtesy of Janet Paulus.)

The lake, which is roughly two-thirds of a mile across, is located in Ela Township. Early settlers included Leonard Loomis, John Robertson, and George Ela, who inspired the name of the township. Ela served as a representative in the state legislature and as the township's first postmaster. The post office, which was named Surryse and later changed to Ela, operated out of his home. (Courtesy of Janet Paulus.)

Many of the first settlers in the area came looking for fertile land to farm. Prairies lined with trails created by Native Americans surrounded the lake as far as the eye could see. Wildlife, including wolves that often threatened farm animals, roamed those prairies in the 1800s. (Courtesy of Janet Paulus.)

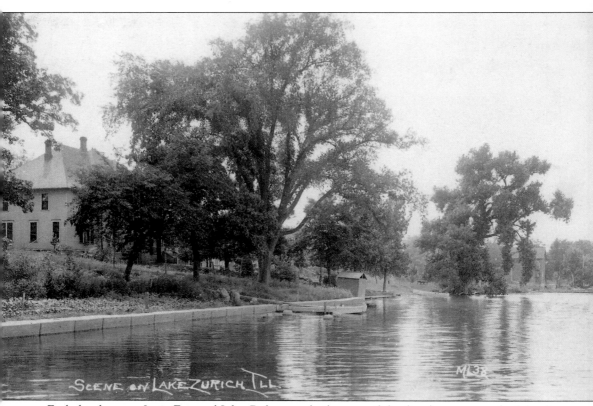

SCENE ON LAKE ZURICH ILL.

Early landowners Isaac Fox and John Robertson built some of the first homes near the lake. In the mid-1850s, Robertson owned more than 1,000 acres of farmland. He also served as one of Ela Township's highway commissioners. He was shot and killed by a neighbor over a dispute that involved the construction of a public road. (Courtesy of Janet Paulus.)

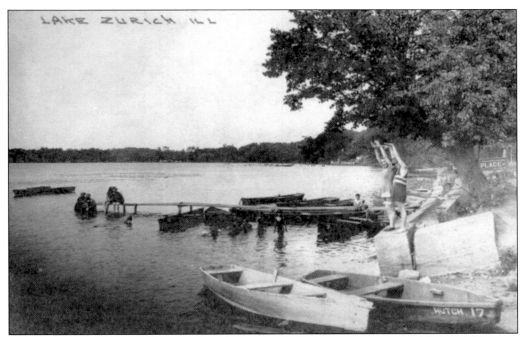

A song about Lake Zurich's beauty inspired the following lyrics: "Let us go to the lake like a heavenly eye, I will show you the waters waving restless and shy: On the face there is dancing the fishermen's boat, And the summer guests bathing and swim in the float." (Courtesy of Janet Paulus.)

The song continues: "And a park there is too and so many good things, And a school and a church where the choir singer sings. A hotel and a stage and some stores and a hall, And a golf club, a railroad, fresh water for all." (Courtesy of Janet Paulus.)

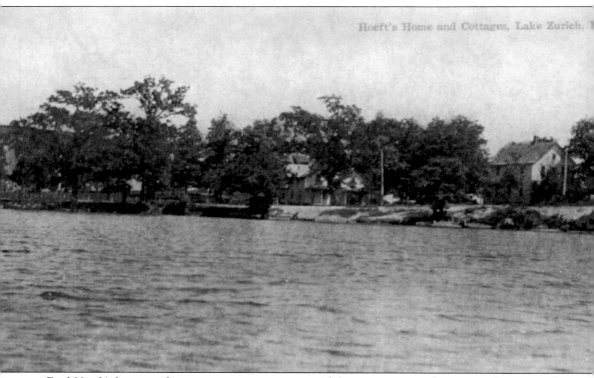

Fred Hoeft's home and summer cottages were one of the many resorts that cropped up around Lake Zurich in the early 1900s. Guests who stayed there could expect to pay $1.50 per day or $8 a week. Less expensive rooms could be rented elsewhere for as little as 50¢ a day. Hoeft served as mayor of Lake Zurich for a brief period in the early 1900s. (Courtesy of Janet Paulus.)

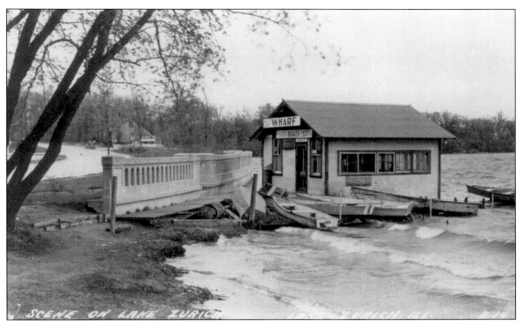

August Froelich operated the wharf shown in this postcard. He and the Pierce family owned much of the lake bed in the late 1920s and were protective of it. Froelich was known to patrol the waters and even arrest trespassers. Froelich and the Pierces told owners of the various resorts in town that it would cost them $10 each season for any boats that wanted to use their private waters. (Courtesy of the Ela Historical Society.)

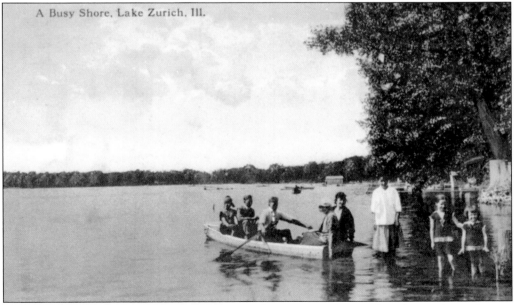

Resort owners sought a temporary restraining order to prevent boaters from being charged to use the lake. But in 1932, the Illinois Supreme Court sided with Froelich and the Pierces, who entered the legal battle to gain ownership of land beneath the lake. From 1932 to 1944, boats paid fees for lake access. (Courtesy of Janet Paulus.)

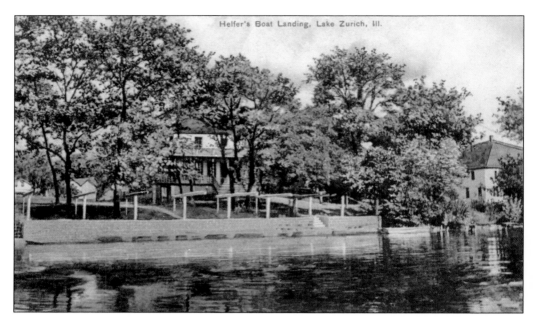

Helfer's Boat Landing, Lake Zurich, Ill.

Herman Helfer owned a farmhouse on the lake that he operated as the Lakeside Hotel. He also owned some cottages. This postcard shows Helfer's boat landing. Helfer also provided a beach for swimmers. Guests at Helfer's hotel could stay by the day or week. The Lakeside Hotel later became the Farman Hotel. Guy Farman took over ownership of the hotel in 1929, operating with 15 rooms. The hotel also featured a restaurant, and by 1965, more than two dozen people served on its staff. Guy Farman died in 1963. His son Guy "Bud" Farman took over as manager. (Courtesy of Janet Paulus.)

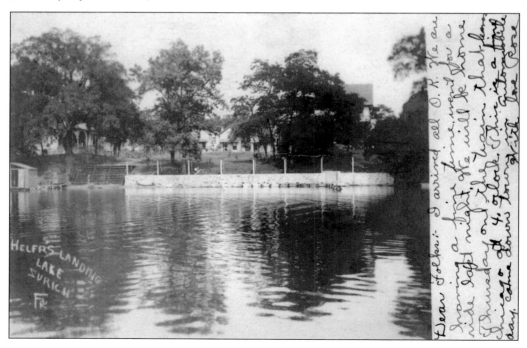

Among the favorite pastimes of summer resort guests was canoe sailing. Lake Zurich's calm waters provided the perfect setting for the sport. Canoes could launch off the various boat landings that surrounded the lake. Sailors could spend their days on the water while others relaxed by the shore. (Courtesy of Janet Paulus.)

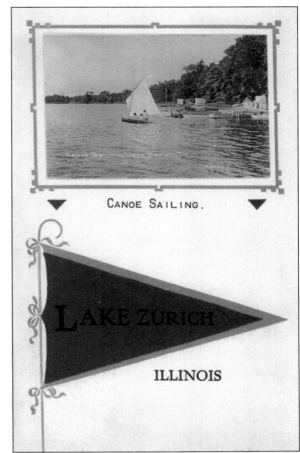

CANOE SAILING.

LAKE ZURICH

ILLINOIS

A solitary boat sailing on Lake Zurich is pictured in this postcard. While summer was undoubtedly one of the busiest times for recreation on the lake, winters also drew sportsmen to the frozen waters. Iceboats could be seen on the lake in the early 1900s during the cold months. (Courtesy of Janet Paulus.)

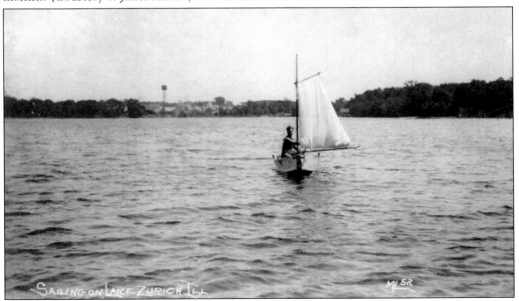

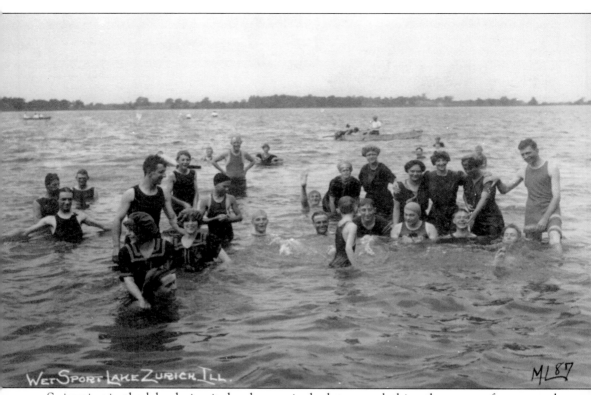

Swimming in the lake during its heyday required a lot more clothing than now—for men and women alike. While the men might have worn sleeveless attire with long swim trunks, women often donned short-sleeve wool outfits to bathe in, with hats to protect their hair. (Courtesy of the Lake County Discovery Museum.)

The two women in this photograph are relaxing on a boat, and the seawall along Illinois Route 22 is visible in the background. Constructed in 1928, the original seawall was made of concrete and featured openings in four different locations so that visitors could easily get out onto the lake. (Courtesy of the Ela Historical Society.)

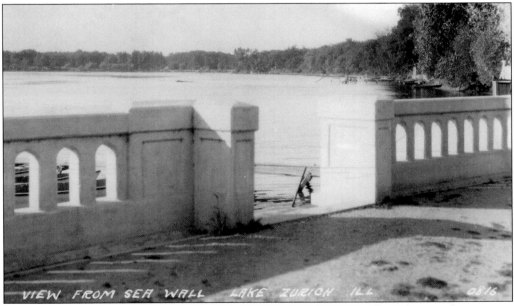

One of the openings that allowed lake access is shown in this postcard. Without such openings, boaters and beachgoers would have had to walk to either end of the 127-foot-long seawall to get to the water. The access points provided much relief on hot summer days. (Courtesy of Janet Paulus.)

People could relax and soak up some summer sun on benches near the lake or right on a pier that extended from the seawall. Fishermen could also cast their lines out into the water from a wooden pier that ran along the length of the seawall. (Courtesy of the Ela Historical Society.)

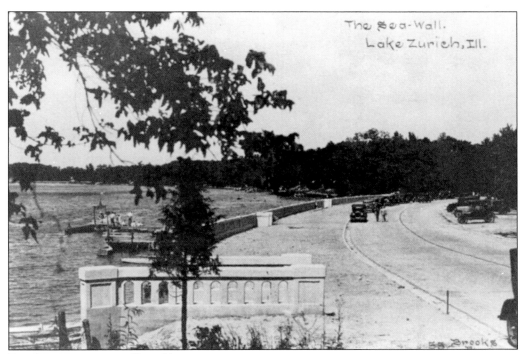

The Sea-Wall.
Lake Zurich, Ill.

But the concrete seawall could not last forever. After nearly 40 years, it began to crumble, and in 1965, Ela Township supervisor Harry Knigge reported the wall to be in dangerous condition and leaning into the lake by 15 inches. In 1967, a steel seawall was built by the state. (Courtesy of the Ela Historical Society.)

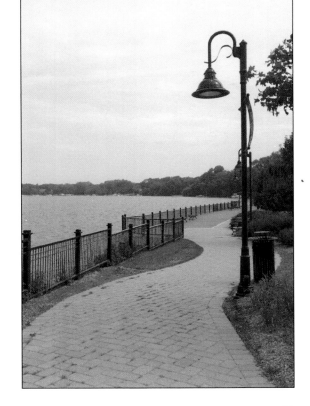

Much like in its early days, a seawall of sorts still runs along Lake Zurich's shore. It looks nothing like the original concrete structure. A black, wrought-iron fence now stands at the edge of a promenade near the water. Street lighting and benches also were added. (Photograph by Michael Flynn.)

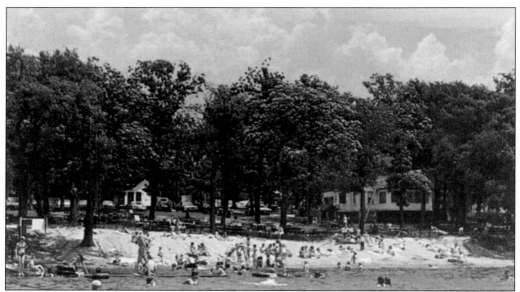

This photograph shows swimmers frolicking on the beach at Breezewald Park along Old Rand Road in 1982. The park was a popular destination for area residents to bring their families on hot summer days. Children and their parents could cool off in the water and picnic in the park. (Courtesy of the Ela Historical Society.)

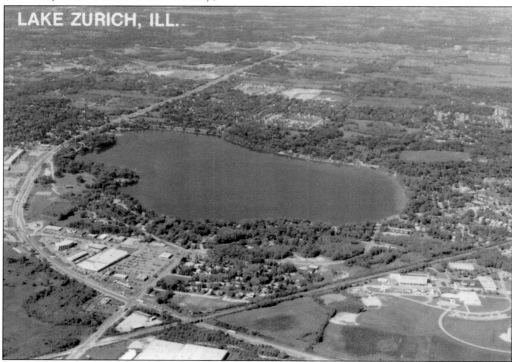

LAKE ZURICH, ILL.

This c. 1965 aerial photograph looking north over Lake Zurich shows a more modern overview of the village and the lake. US Route 12 is the most dominant road shown in the postcard, while Illinois Route 22 can be seen snaking around the lake. (Courtesy of Janet Paulus.)

Two

THE TOWN

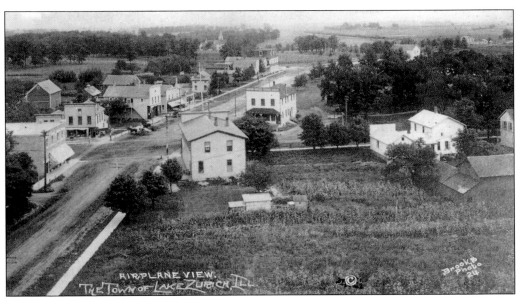

Founded in 1836, Lake Zurich was officially incorporated as a village on September 29, 1896. Some of the first buildings in town included a general store, a couple of blacksmith shops, and landowners' homes. This postcard shows an early-1900s view of downtown looking east along Main Street. (Courtesy of Janet Paulus.)

Main St., Lake Zurich, Ill.

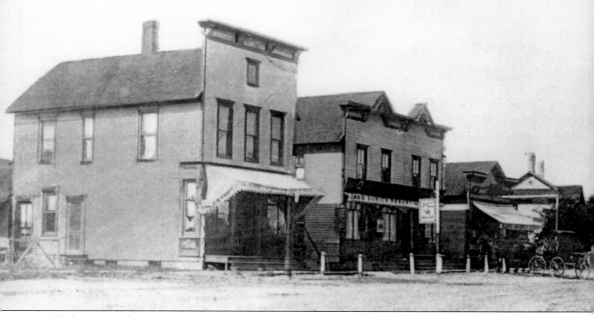

While many of the first settlers in town came from New England to farm the land, plenty of German immigrants also flocked to the Lake Zurich area after 1850. One of those early immigrants was Henry Seip, who moved to town in 1874, bought a store, and later served as postmaster in Lake Zurich. Henry Hillman opened the first butcher shop (pictured on the left) in the 1880s. (Courtesy of the Ela Historical Society.)

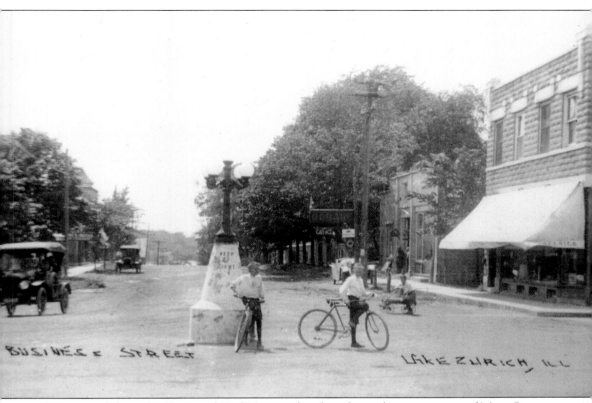

This postcard shows Ira Ernst and Carl Tonne riding bicycles at the intersection of Main Street and Old Rand Road. The Tonne family ran a restaurant and rooming house in town for more than three decades. Members of the Ernst family operated a department store and general store. (Courtesy of the Ela Historical Society.)

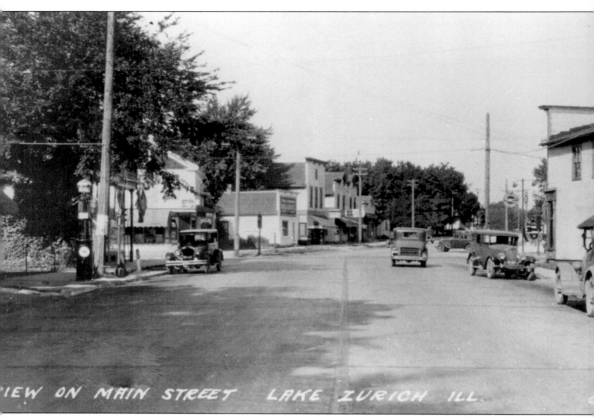

VIEW ON MAIN STREET LAKE ZURICH ILL.

Other early settlers included Herman Prehm, who opened the first hardware store near Main Street and Old Rand Road. Old Rand Road was originally known as Paine Street in honor of Seth Paine. A gas pump visible in the left part of the photograph was located at a garage owned by Philip Young. (Courtesy of the Ela Historical Society.)

This photograph shows Lake Zurich's original village hall. A livery stable was located on the first level, and meeting rooms were housed on the second floor. The bell at the top of the building was used to alert residents and call for help in the event of a fire. (Courtesy of the Ela Historical Society.)

The Lake Zurich Creamery, which was built in the 1880s, was located just down the street from the original village hall. Farmers would line up along Main Street in their horse-drawn wagons in front of the creamery with their milk. The creamery processed and bottled the milk before delivering it to customers. (Courtesy of the Ela Historical Society.)

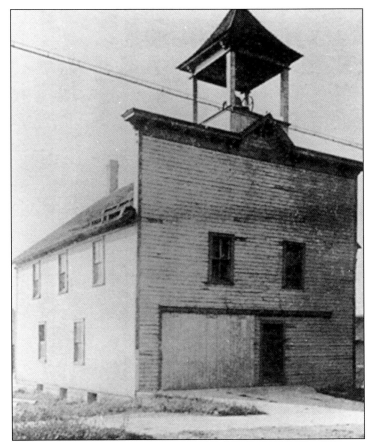

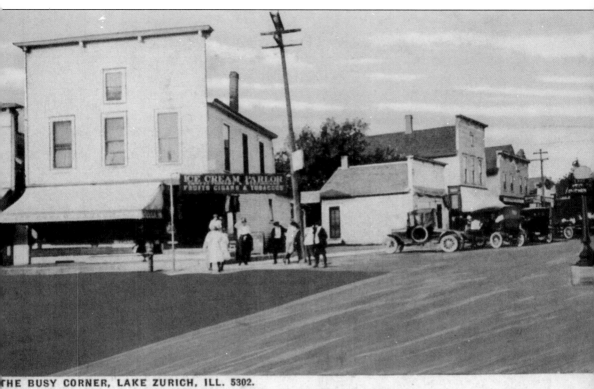

THE BUSY CORNER, LAKE ZURICH, ILL. 5302.

This postcard shows another view of Main Street, which originally was known as Robertson Avenue. The street was named after early settler, substantial landowner, and Ela Township Highway commissioner John Robertson, who was killed by a neighbor in the late 1870s. The road was gravel until being paved in 1927. (Courtesy of Janet Paulus.)

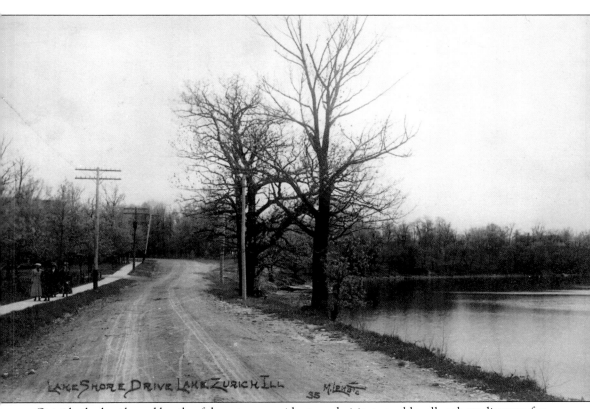

LAKE SHORE DRIVE LAKE ZURICH ILL 35 M.LEHRER

Outside the hustle and bustle of downtown, residents and visitors could walk a short distance for some peace along the lake. This postcard shows a view of Lake Shore Drive in 1909. The women pictured are Lydia Hokemeyer Blau, Tillie Buesching Howe, Emma Schaefer Hans, and Edna Prusia Grasso. (Courtesy of Janet Paulus.)

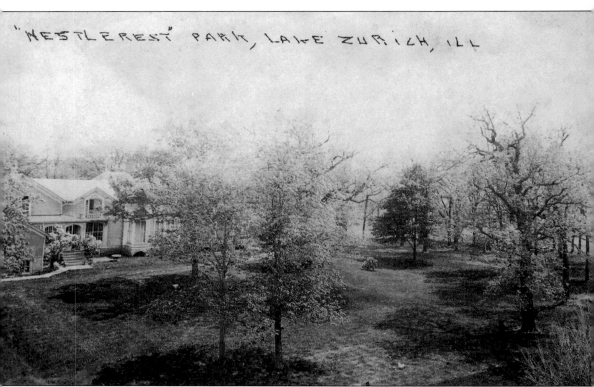

"NESTLEREST" PARK, LAKE ZURICH, ILL

Isaac Fox was responsible for building one of the first homes on Lake Zurich's south side in what became Nestlerest Park. Dick Barrie purchased the park in 1950. Gerhardt and Lorraine Block managed the resort. Lorraine Block did all the cooking and cleaning at the park. (Courtesy of Janet Paulus.)

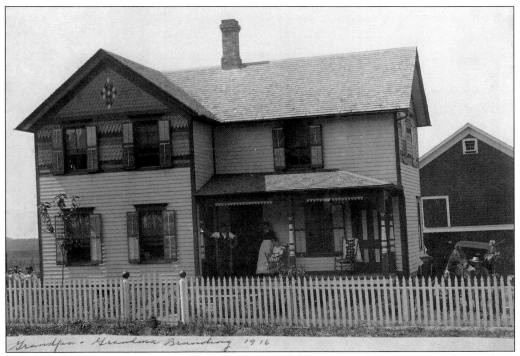

This 1916 photograph shows Henry and Bertha Branding in front of their two-story home along Old Rand Road. German immigrants, they came to Lake Zurich in the late 1800s. One of their sons, Emmet, was born in Lake Zurich in 1893. They also had another son, Ed. (Courtesy of Howard and Karen Branding.)

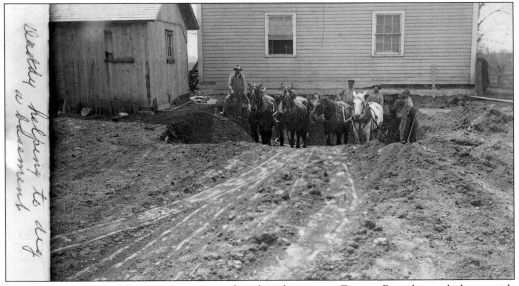

The horses shown in this picture were used to dig a basement. Emmet Branding is helping with the job. He was one of the people in town who erected a strip of buildings along Main Street. Some of those buildings later housed businesses run by his son Howard Branding. (Courtesy of Howard and Karen Branding.)

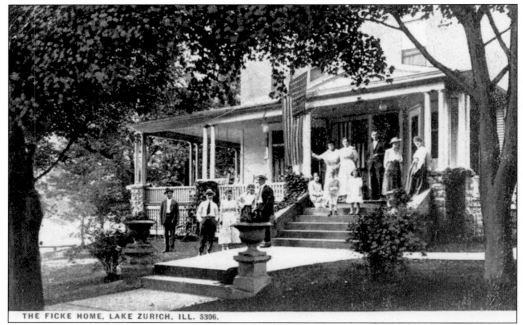

THE FICKE HOME, LAKE ZURICH, ILL. 5306.

Other early settlers included Frank Scholz, who started up the first blacksmith shop, and Emil Ficke, who set up a store. The Ficke family owned a large home in Lake Zurich, and in the summer months, Frieda Ficke operated an ice cream parlor out of its living room. Emil Ficke served as mayor of Lake Zurich in the early 1900s. (Courtesy of the Ela Historical Society.)

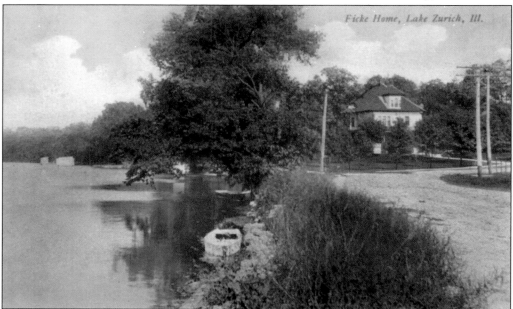

Ficke Home, Lake Zurich, Ill.

This postcard shows a view of the Ficke home and its proximity to the lake. Emil Ficke was a part of Lake Zurich's original village board, serving as its first treasurer before becoming mayor. Ficke spent time as village clerk, trustee, and school board member. He even served as postmaster. (Courtesy of Janet Paulus.)

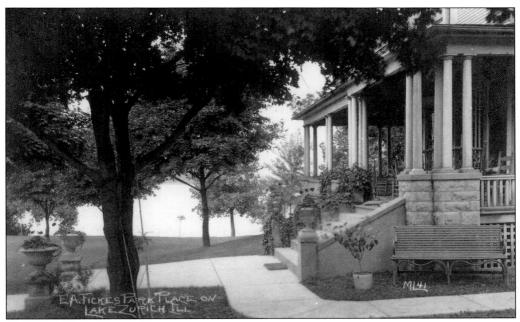

Another view of the Ficke home shown in this postcard features the lake in the background. The Ficke family operated one of the popular summer resorts in town. Rooming rates ranged from $2 to $3.50 per day, which was at the higher end of pricing at the time. (Courtesy of Janet Paulus.)

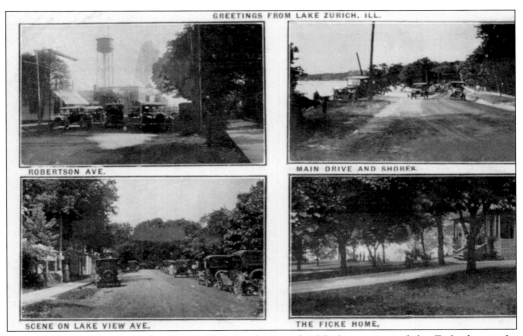

One of the many postcards of Lake Zurich, this one highlights a view of the Ficke home. In addition, it shows Robertson Avenue, which was later known as Main Street, and two scenes of cars traveling along tree-lined roads by the lake. (Courtesy of Janet Paulus.)

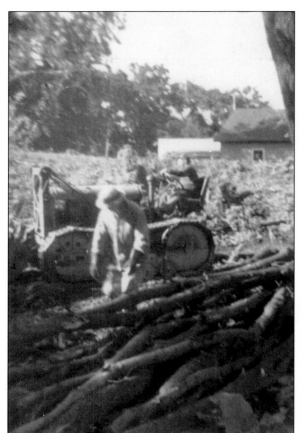

This early-1940s picture shows a worker clearing the fields of what is now Fred Blau Park. The establishment of the park was a project of the Lions Club in Lake Zurich. Originally called Lions Park, in 1978, the organization renamed it after Blau, a longtime Lions member and barbershop owner. (Courtesy of the Lake Zurich Alpine Lions Club.)

This photograph shows the cleared land. According to a log kept by the Lions Club from 1942 to 1943, the park project "involved a lot of hard work clearing trees and leveling land." The Ela Town Hall, built in 1865 on land donated to the township by Isaac Fox, is visible in the background. The building now houses the Ela Historical Society. (Courtesy of the Lake Zurich Alpine Lions Club.)

The Lions Club bought the acreage for the park for $500 from the defunct PLZ&W Railroad, which was designed to connect Palatine, Lake Zurich, and Wauconda with a Chicago line. In 1911, the railroad's first tracks were put down. But the railroad struggled as automobiles became more prevalent, and little more than a decade later it was out of business. (Courtesy of the Lake Zurich Alpine Lions Club.)

Although the wooden archway is no longer standing, the well-known lion drinking fountain remains in Fred Blau Park, where the Lions Club sponsors the popular Alpine Fest each summer. The Lions began in Lake Zurich in 1939 and held their first meeting at the Farman Hotel. By 1944, the Lions bought a majority of the lake bed and lakefront property to ensure public access. (Courtesy of the Lake Zurich Alpine Lions Club.)

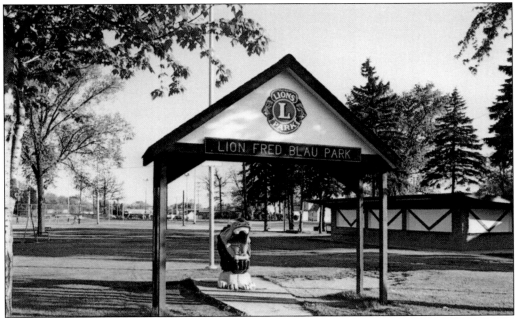

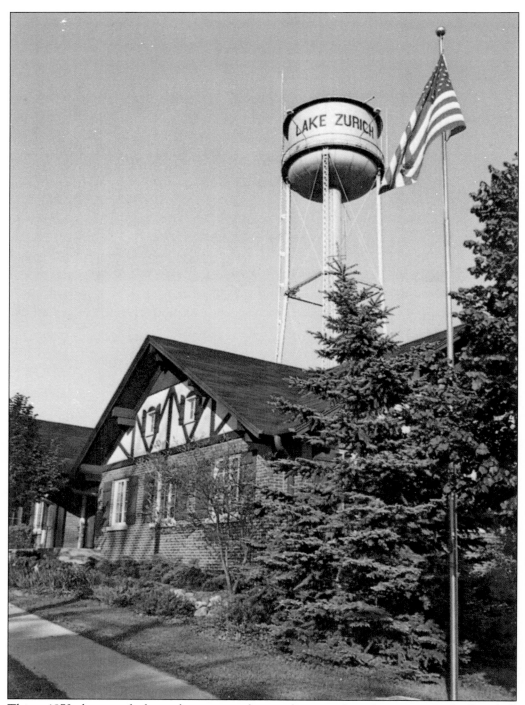

This c. 1973 photograph shows the property that was home to the police station and village hall for decades. The village hall operated there from 1940 to 1986. The police remained for years after that. The water tower in the background was a well-known landmark built in 1911. A siren on the tower would sound off at noon. (Courtesy of Henry "Hank" Paulus.)

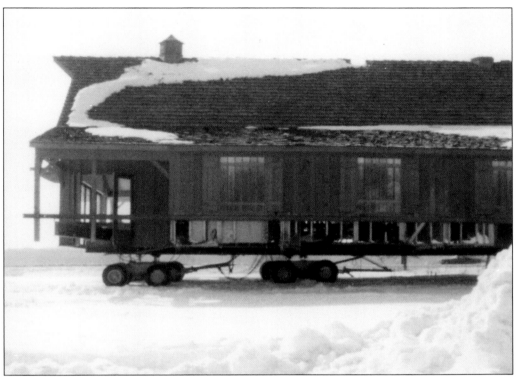

These photographs show a barn being moved to Paulus Park in the 1970s. The barn was used as the sales office for the Old Mill Grove subdivision in the eastern part of Lake Zurich. The subdivision featured ranch homes, two-story houses, and bi- and tri-level homes. They ranged in size from three to five bedrooms and one to two and a half bathrooms. The developers, 3H Building Corporation, donated the barn to the village for a nominal fee. The village's Parks and Recreation Department has operated out of the barn for years. (Courtesy of Henry "Hank" Paulus.)

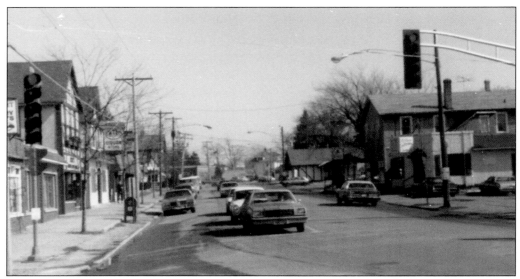

A view of Main Street around 1975 shows the Lions Club building just off to the right and a strip of buildings on the left that housed businesses, including a liquor store, restaurant, and floristry. The village hall would later be located in the building across the street from the Lions. (Courtesy of Henry "Hank" Paulus.)

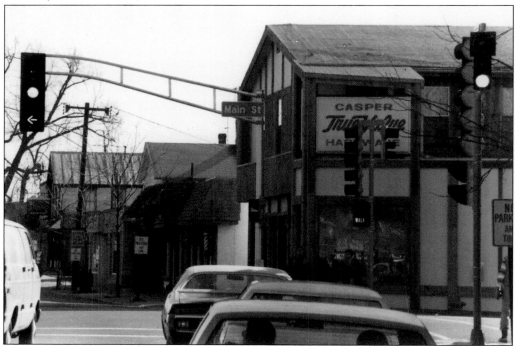

This view of the intersection of Main Street and Old Rand Road shows the old Casper Hardware store. While various businesses operated out of that location over the years, including Carl Ernst's department store from 1907 to 1922, the building was originally constructed by Emil Ficke in 1890. Ficke, who became postmaster, ran a general store and post office there. (Courtesy of Henry "Hank" Paulus.)

Three

THE PEOPLE

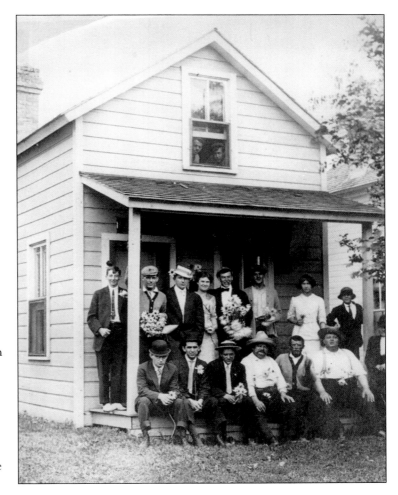

Just as the lake is the town's heart, it has been the people of Lake Zurich who have kept that heart pumping. And they have been honored throughout the village with parks and schools named after them. While some names are more recognizable than others, their combined contributions have made Lake Zurich what it is today. This photograph shows a wedding party posing on a summer cottage porch. (Courtesy of the Ela Historical Society.)

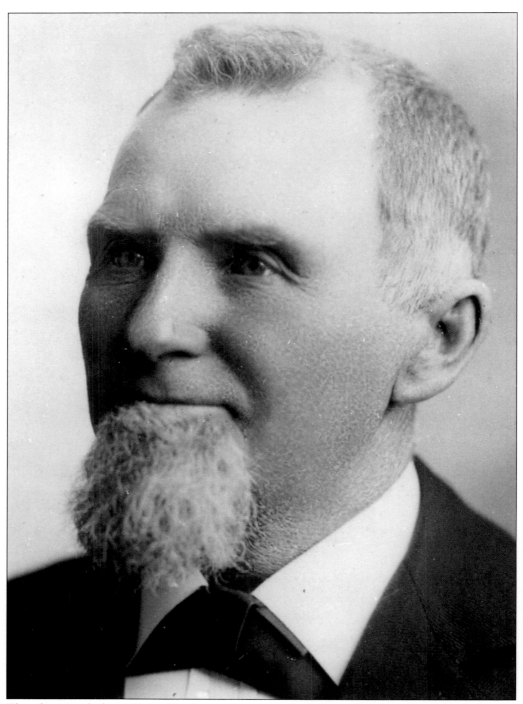

This photograph shows Henry Berghorn, who operated a farm on Buesching Road that he bought in the late 1800s. Berghorn was also among the first elders in what is now known as St. Peter United Church of Christ on Church Street. He served as the church's council president from 1906 to 1908. (Courtesy of St. Peter United Church of Christ.)

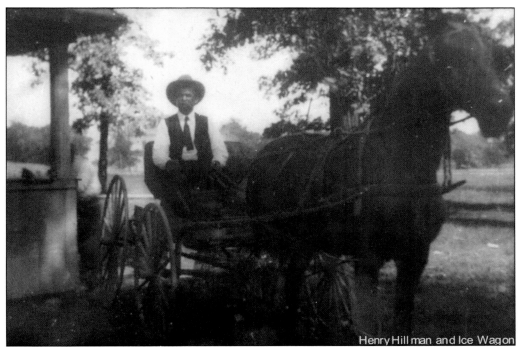

Henry Hillman and Ice Wagon

These photographs show Henry Hillman. He opened the town's first butcher shop and went on to become a cattle and hog dealer. Otto Giese ran the butcher shop later as a store. Other members of the Giese family also operated businesses out of the building. In addition to his work as a butcher, Hillman was one of the founding fathers at St. Peter United Church of Christ. He and his family remained very active with the church. His wife, Zoe Wienecke, was a Sunday school teacher at St. Peter's. (Above, courtesy of the Ela Historical Society; right, courtesy of St. Peter United Church of Christ.)

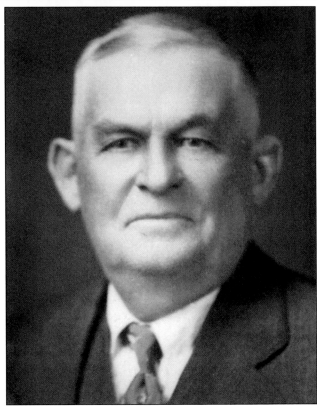

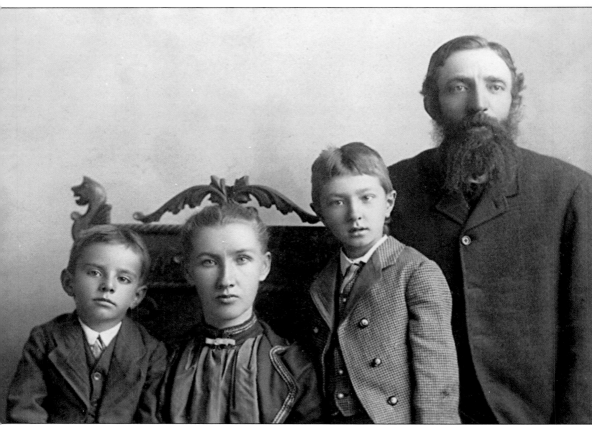

A portrait of the Tonne family shows Dick Tonne, his wife, and their two sons, Walter and Eddie. Some of the family's relatives went on to run Tonne's Eat Shop, which was built in 1914. It operated as a restaurant and rooming house until 1951. (Courtesy of the Ela Historical Society.)

This photograph shows Roy Loomis and two of his friends preparing his iceboat around 1910. During the early 1930s, Loomis and his wife, Josephine Catlow Loomis, lived in a two-story house on Old Rand Road. The couple had three children, Marian, Calvin, and Spencer, who went on to become a longtime teacher and principal at May Whitney Elementary School. Another school in Lake Zurich was named after Spencer Loomis. (Courtesy of the Ela Historical Society.)

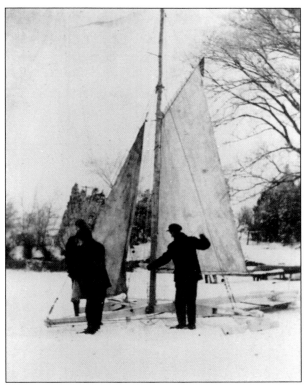

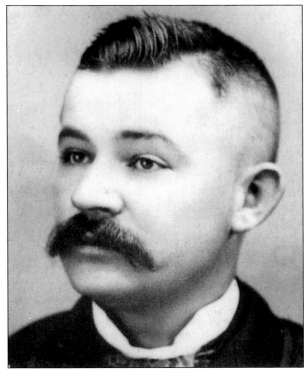

William Prehm served as Lake Zurich's chief of police from the time he was appointed in 1902 until 1933. In addition, Prehm served as a village trustee for a period. Prehm's son, also named William Prehm, served as police chief beginning in the late 1940s. (Courtesy of St. Peter United Church of Christ.)

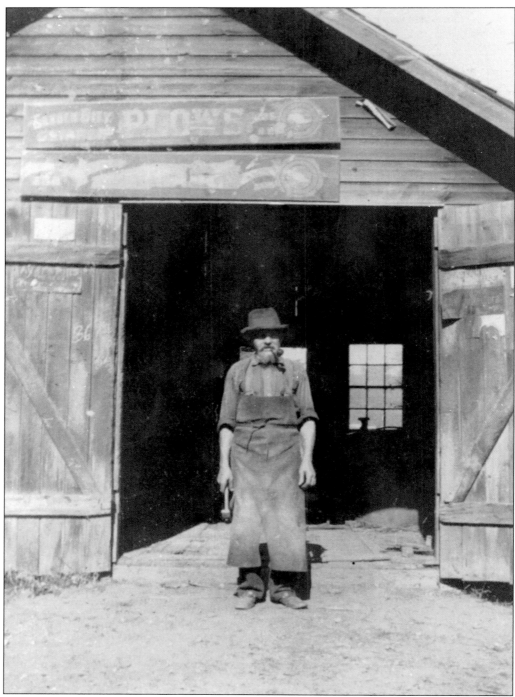

Frank Scholz (shown in this picture) and William Eichmann served as Lake Zurich's first blacksmiths. Scholz worked as a blacksmith from 1871 to 1932. His shop was located on Old Rand Road. Eichmann helped incorporate Lake Zurich and went on to serve as one of the first members of the Lake Zurich Village Board. (Courtesy of the Lake County Discovery Museum.)

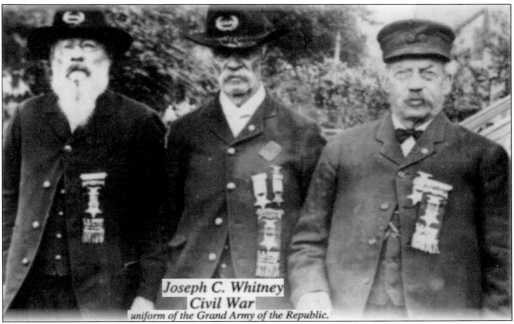

Joseph C. Whitney
Civil War
uniform of the Grand Army of the Republic.

Joseph Whitney (center), donning the uniform of the Grand Army of the Republic, incorporated Lake Zurich in 1896 along with William Buesching, William Eichmann, Emil Ficke, Charles Kohl, and Herman Prehm. Serving in the Civil War, Whitney helped pick up soldiers injured on the battlefield. (Courtesy of the Ela Historical Society.)

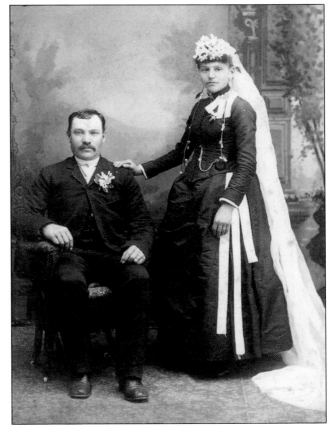

This early-1900s photograph shows Herman Schneider with his wife. Schneider served as council president at St. Peter United Church of Christ from 1909 to 1912. Other council presidents at the church included William Buesching, Henry Berghorn, and Ed Umbdenstock. (Courtesy of St. Peter United Church of Christ.)

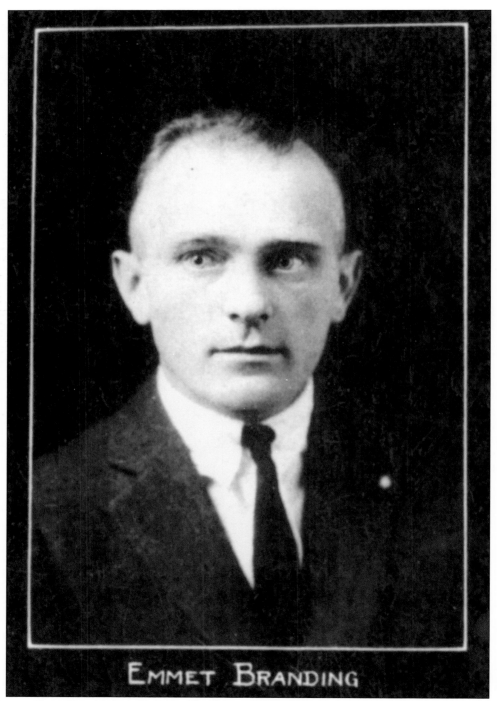

EMMET BRANDING

Emmet Branding was born in Lake Zurich in 1893 to German immigrants Bertha and Henry Branding. Emmet Branding went on to construct some of the buildings along Main Street that ended up being operated as businesses by his son Howard Branding and his family. (Courtesy of the Ela Historical Society.)

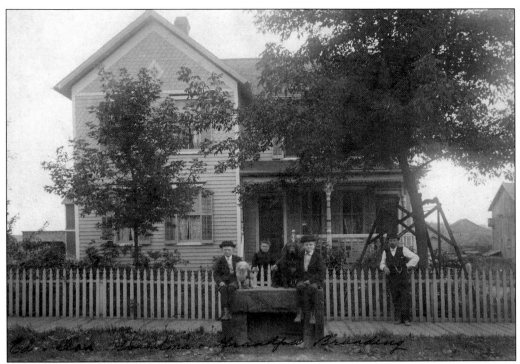

This photograph (above) shows Ed and Emmet Branding with their parents, Bertha and Henry Branding, in front of their home on Old Rand Road. The building pictured below was run as a saloon by Henry Branding. The saloon was located on the site of the building that became the Koffee Kup restaurant, which was owned and operated by Emmet Branding's son Howard Branding from 1969 to the mid-1970s. The Koffee Kup was an extension of the barbershop run by Fred Blau from 1909 to the 1950s. In addition, the Brandings ran the Lake Zurich floristry, also an extension of the Koffee Kup, from 1975 to 2008. (Courtesy of Howard and Karen Branding.)

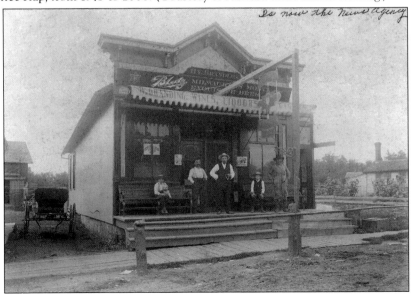

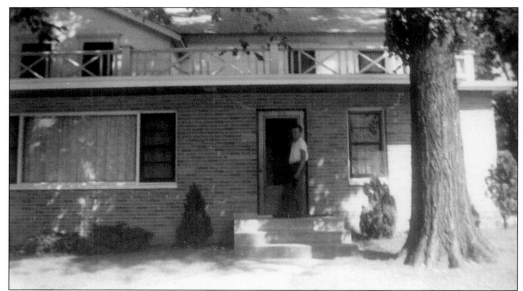

Howard Branding stands on the steps of the home he lived in with his parents, Emmet and Sophie Branding, for more than a decade beginning in 1951. Howard Branding married his wife, Karen, in 1964. The couple went on to have two daughters, Kristin and Amy. The house was located on Main Street near the floristry and the Koffee Kup. (Courtesy of Howard and Karen Branding.)

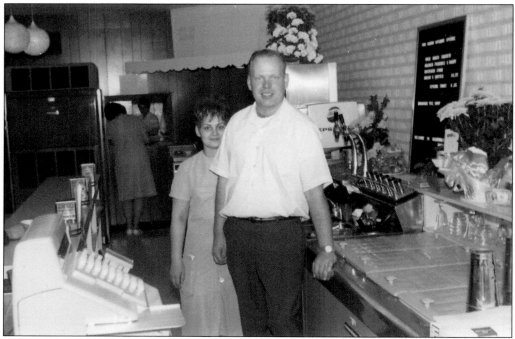

Seen here are Howard and Karen Branding on opening day of the Koffee Kup on Main Street in 1969. Howard Branding was born in Oak Park and moved to Lake Zurich when he was 11 years old. He and his family continue to call Lake Zurich home. (Courtesy of Howard and Karen Branding.)

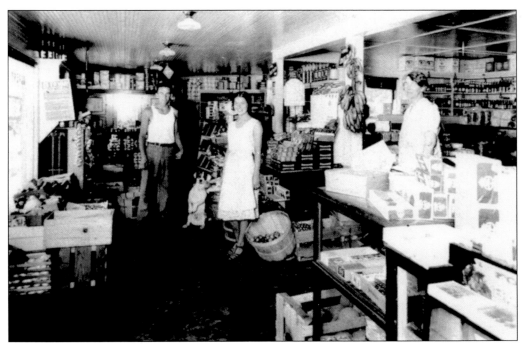

From left to right, Ira, Irene, and Ida Ernst pose inside their general store on Main Street. Ida Ernst's husband, Carl, ran a department store on Old Rand Road from 1907 to 1922. (Courtesy of the Ela Historical Society.)

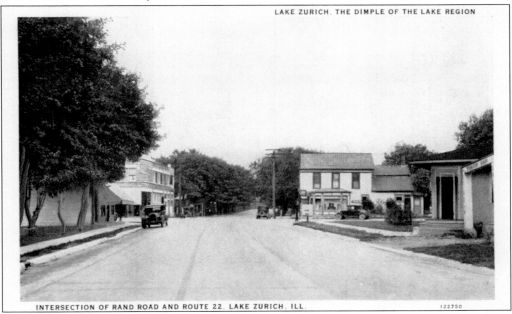

This 1920s view of Old Rand Road shows where Carl Ernst's department store was located (on the left near the automobile). Built by Emil Ficke in 1890, the business was run as a general store and post office. Charles Kohl, assistant postmaster, then set up a general store at the site before selling it to Carl Ernst in 1906. (Courtesy of the Curt Teich Postcard Archives.)

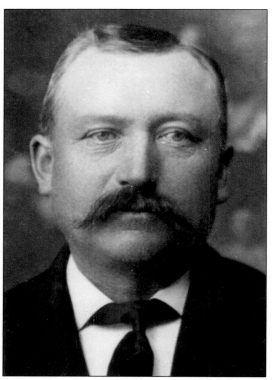

William Buesching was one in a group of men who helped incorporate Lake Zurich as a village. He also served as one of the first members of the Lake Zurich Village Board. In addition, he was active with St. Peter United Church of Christ, serving as its council president in the early 1900s. (Courtesy of St. Peter United Church of Christ.)

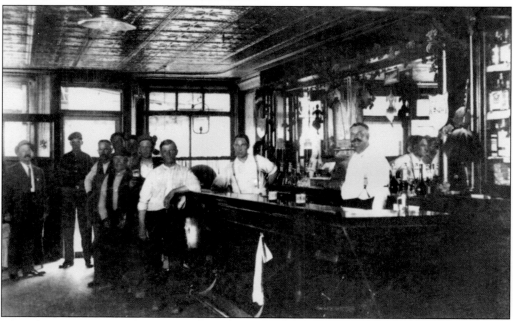

This photograph shows Fred Seip's saloon around 1914. Other saloons in the area at the time included one run by Ernst Schenning. Henry Seip, who was Fred Seip's father, operated a general store on Main Street from 1874 to 1902. Seth Paine originally constructed that building. (Courtesy of the Ela Historical Society.)

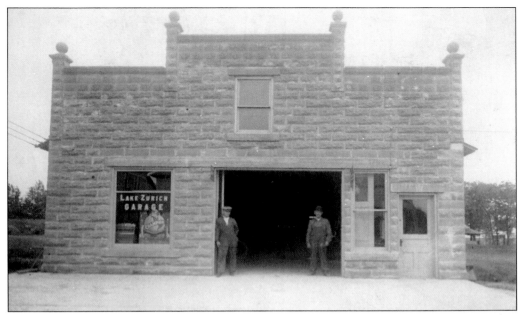

Albert and Herman Prehm stand in their Main Street garage, which was the first of its kind in the village and later became the home of the Lions Club. Herman Prehm served as president of the Lake Zurich Village Board from 1898 to 1901. (Courtesy of the Ela Historical Society.)

This photograph shows an exterior view of Prehm's garage. The Prehm family is well known in Lake Zurich for the countless years its members devoted to public service in one form or another. Various family members were involved with St. Peter United Church of Christ and served on the village board and the police department. (Courtesy of the Lake County Discovery Museum.)

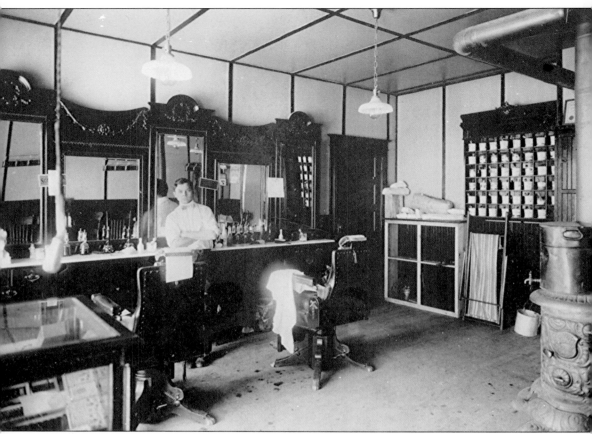

Fred Blau is pictured in his barbershop in 1912. Customers could get a haircut for 25¢, a shave for 10¢, and free cigars if they chose. Blau came to Lake Zurich in 1909 and went on to be an active member of the community. A longtime Lions Club member, Blau helped the organization acquire the land for the park that now bears his name and secure hundreds of acres of lake bed to ensure public access to Lake Zurich. (Courtesy of the Ela Historical Society.)

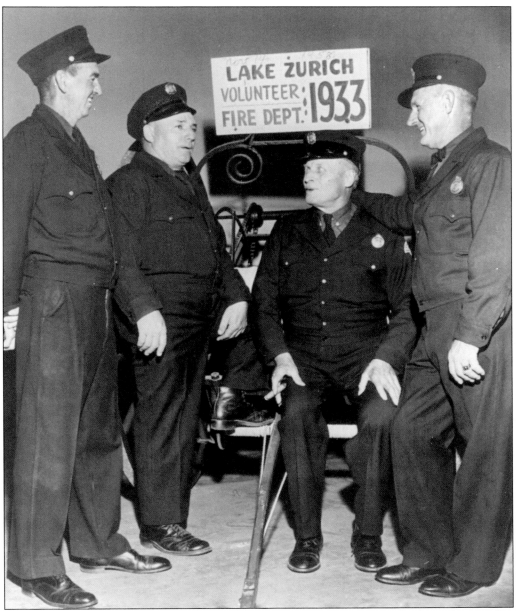

This 1958 photograph shows some of the charter members of Lake Zurich's volunteer fire department on its 25th anniversary. From left to right are Ira Ernst, Julius "Dud" Geary, William Buhr, and William Pohlman. Buhr served as the department's first fire chief. Geary served as chief three different times between the early 1940s and the early 1950s. (Courtesy of the Ela Historical Society.)

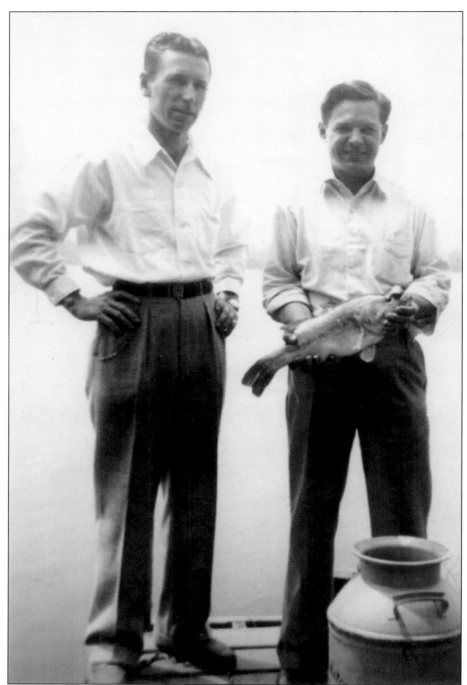

Eugene Frank posed in 1946 with Harold Giese and the bass he caught from Lake Zurich. Frank, whose family ran a news agency, and Giese, whose family operated a shoe shop and department store, were both active with the Lions Club. The Lions would stock the lake with fish and sometimes tagged one, offering a prize to anyone who could catch it. (Courtesy of the Lake Zurich Alpine Lions Club.)

Henry "Hank" Paulus served as mayor of Lake Zurich from 1969 to 1989. He also served as village clerk for a number of years and as a trustee for several months before becoming mayor. A large park near the lake, formerly known as Pleasant Acres, was named after him. (Courtesy of Henry "Hank" Paulus.)

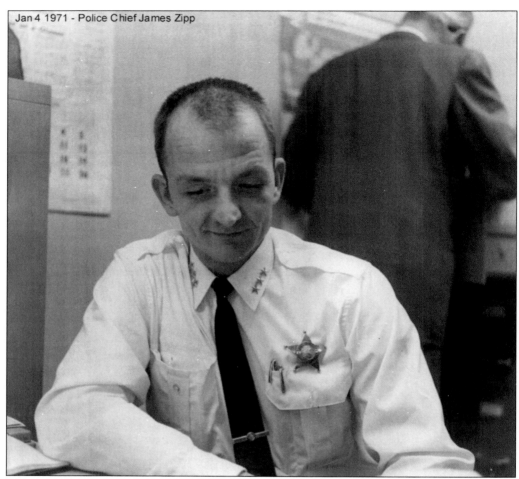

Jan 4 1971 - Police Chief James Zipp

This 1971 photograph features James Zipp, a Lake Zurich police officer who succeeded William Prehm as police chief in 1968. Prehm's father, also named William Prehm, served as police chief from 1902 to 1933. In 1946, the department included only two members. By the time Zipp took over, there were nine members of the department. He served as chief for 15 years. (Courtesy of the Ela Historical Society.)

Four

SCHOOLS AND CHURCHES

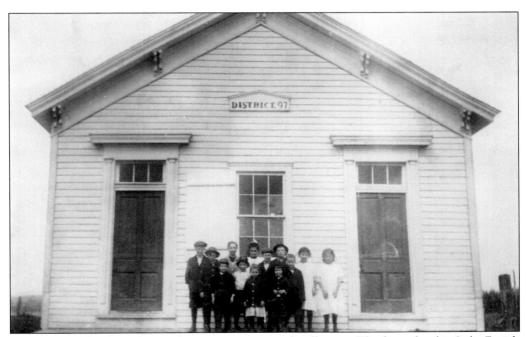

Many of the schools in the area began as one-room schoolhouses. The first school in Lake Zurich started in 1862, with its first teacher being Sarah Adams. There were about 65 children in the school district at the time. This photograph shows children posing on the steps of Pomeroy School in 1911. The school was consolidated with Lake Zurich in 1946. (Courtesy of the Ela Historical Society.)

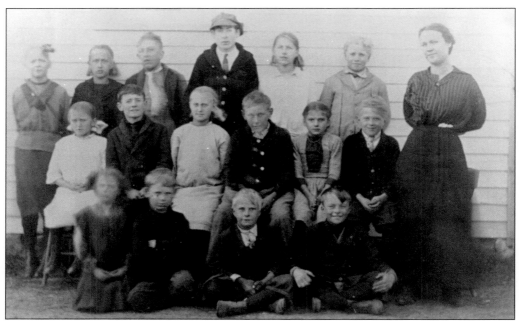

Teacher Josephine Catlow Loomis posed with some of her students at Bennett School in this 1916 photograph. The school consolidated with Lake Zurich in 1946, along with Pomeroy and Fairfield Schools. Josephine Catlow Loomis's son Spencer Loomis went on to become a longtime teacher and the first principal at May Whitney Elementary School. (Courtesy of the Ela Historical Society.)

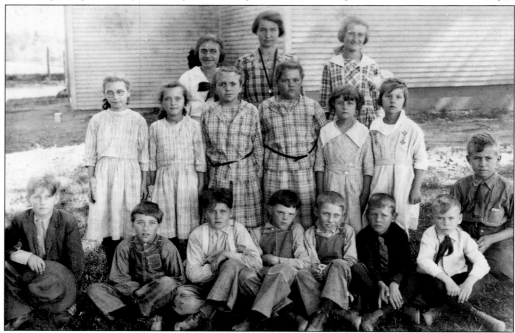

This c. 1920s photograph shows a teacher with her students outside a schoolhouse in town. In the late 1800s and early 1900s, teachers often worked three-month terms in the spring and fall. Parents typically provided boarding for their children's teachers. (Courtesy of the Ela Historical Society.)

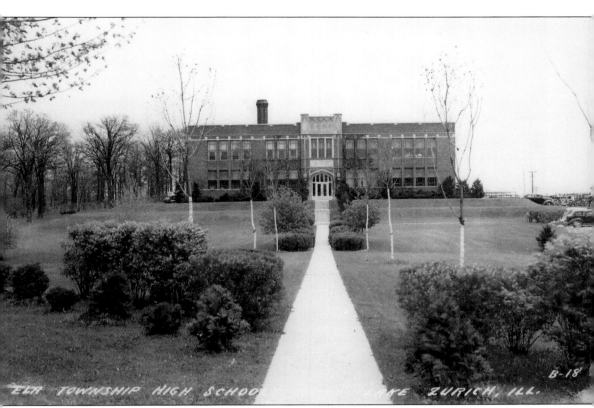

Originally called Ela Township High School, Lake Zurich's first high school occupied space in this building, which was constructed in 1929 and later became the Lake Zurich Junior High School. When it began, the high school was part of District 125. Before becoming Lake Zurich High School, it was called Ela Vernon High School. (Courtesy of Janet Paulus.)

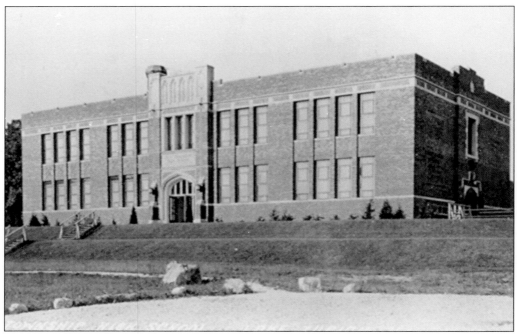

This photograph shows another view of the high school. Several additions to the building occurred over the years, including those in 1952, 1958, and 1961. In 1965, the elementary school district and the high school combined to create District 95. James Watson served as its first superintendent. (Courtesy of the Ela Historical Society.)

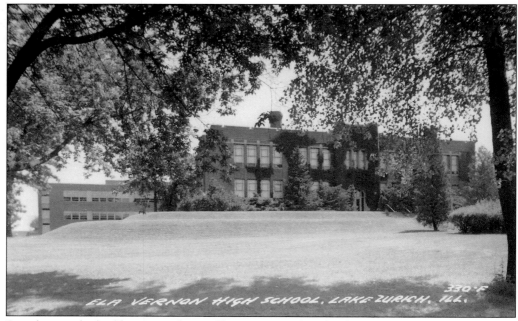

Seen here is the building in its days as Ela Vernon High School. Some of the original planners of the high school in the late 1920s were Walter Prehm, Emil Ficke, August Froelich, and John Fink. (Courtesy of Janet Paulus.)

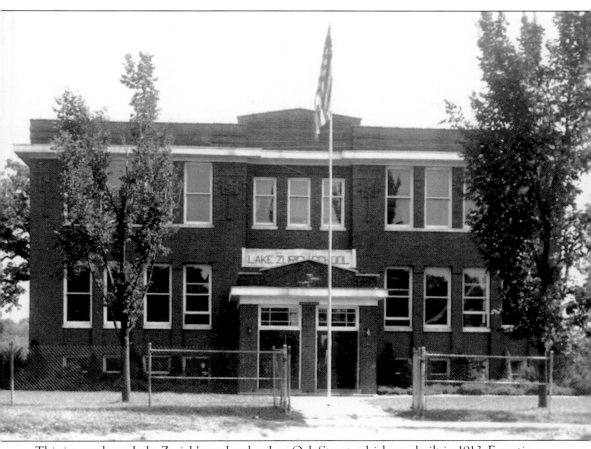

This image shows Lake Zurich's grade school on Oak Street, which was built in 1913. For a time, high school and elementary classes operated out of the building. It also housed a library. (Courtesy of the Ela Historical Society.)

Several churches (including St. Peter United Church of Christ, St. Francis de Sales Catholic Church, and St. Matthew Lutheran Church) have served the Lake Zurich community over the years—some for more than a century. This postcard shows a view looking south on Church Street. St. Peter United Church of Christ is visible in the center at the top of the hill. (Courtesy of St. Peter United Church of Christ.)

Pictured here is an exterior view of St. Peter's in 1920. Some of the church elders included Henry Berghorn, Emil Frank, and Herman Helfer. It began as an evangelical church and was dedicated in 1900. Rev. John Heinrich served as the congregation's first pastor. (Courtesy of St. Peter United Church of Christ.)

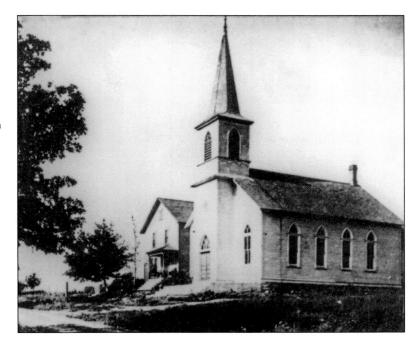

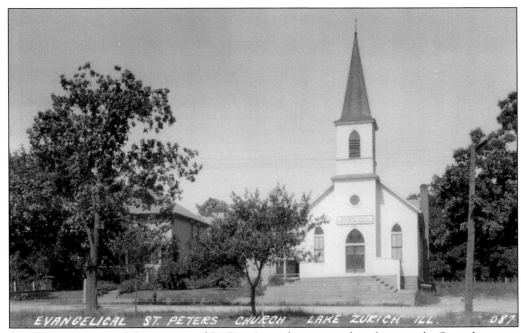

Another early view of the exterior of St. Peter's can be seen in this photograph. Over the years, many organizations in the community have used the church's facilities, including the Boy Scouts, the Girl Scouts, and the Good Shepherd Hospital Auxiliary. (Courtesy of St. Peter United Church of Christ.)

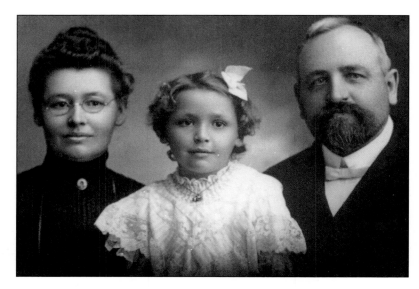

This photograph shows Rev. John Heinrich and his wife with their daughter Marie. Heinrich was pastor from 1901, when the first parsonage was completed, to 1908. He served again as pastor from 1911 to 1918. Early services were held in German. (Courtesy of St. Peter United Church of Christ.)

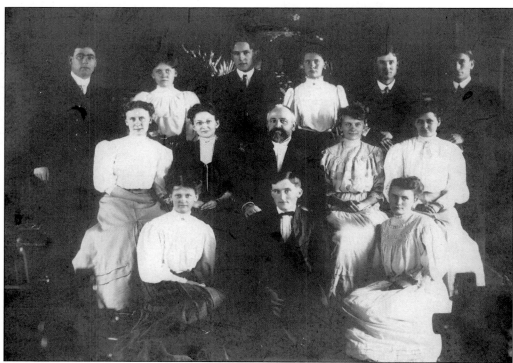

Rev. John Heinrich poses with the first choir at St. Peter's in 1905. From left to right are (first row) Rose Buesching, Fred Buesching, and Lydia Hokemeyer; (second row) Minnie Hokemeyer, Minnie Buesching, Rev. John Heinrich, Tillie Hokemeyer, and Jenny Seip; (third row) John Fink, Carrie Koffen, William Eichmann, Mertie Kuebker, George Berghorn, and Otto Frank. (Courtesy of St. Peter United Church of Christ.)

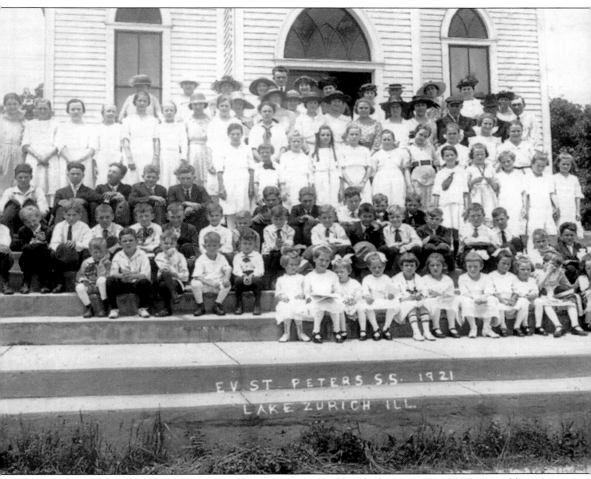

Members of St. Peter's congregation pose on the church's steps in 1921. In 1929, an addition to the church was built to serve as a parish hall. In 1965, a new parsonage was dedicated. By 1972, a new sanctuary, office space, and a fellowship hall were completed. (Courtesy of the Ela Historical Society.)

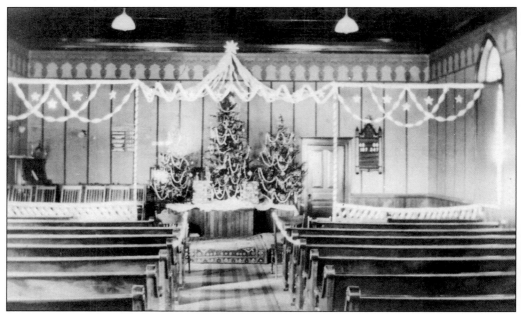

These photographs show views of the sanctuary inside St. Peter's over the years. The photograph above was taken during the Christmas season in 1919. Below is an interior photograph from around 1950. The various pastors of the church included Erich Bizer, Herbert Armstrong, and Stephen Redman. Herman Prehm served as the church's first president, and Henry Kasten served as its first council secretary. Other council presidents included William Buesching and Ed Umbdenstock. Many of the people involved with the church were also leaders in the community. (Courtesy of St. Peter United Church of Christ.)

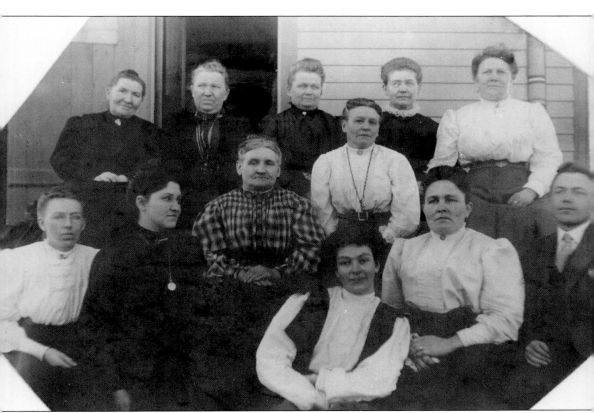

The members of the Ladies Aid of St. Peter's pose in this 1909 photograph with Rev. Theodor Tillmanns. From left to right are (first row) Mrs. Tillmanns (just right of center with arms folded), Mrs. Hillman, and Rev. Theodor Tillmanns; (second row) Mrs. Berghorn, Mrs. Buesching, another Mrs. Buesching, and Mrs. Schneider; (third row) Mrs. Eichmann, Mrs. Sandman, Mrs. Branding, Mrs. Schaefer, and Mrs. Froelich. (Courtesy of St. Peter United Church of Christ.)

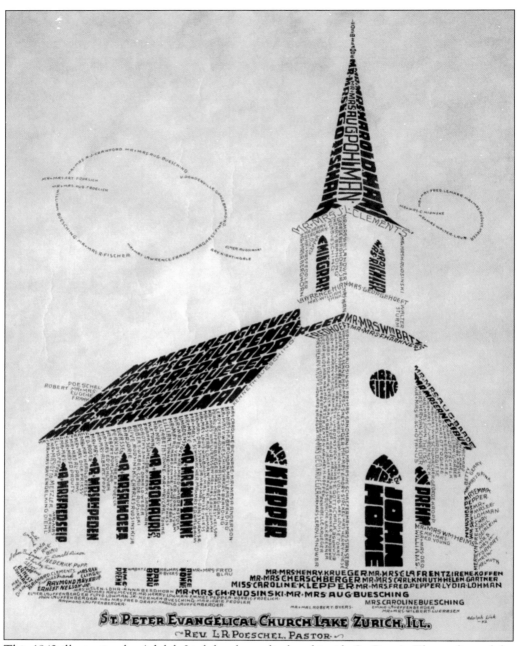

This 1942 illustration by Adolph Link has been displayed inside St. Peter's. The outline of the church, the front steps, and even the clouds were created by using the names of the congregation. Some members included those of the Pohlman, Buesching, and Prehm families. (Courtesy of St. Peter United Church of Christ.)

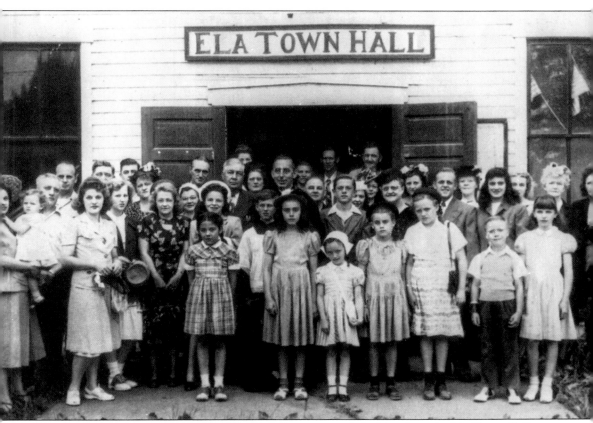

St. Francis de Sales Catholic Church held its first mass in Lake Zurich at the Ela Town Hall in the summer of 1948. Fr. George Ballweber of nearby Buffalo Grove celebrated that mass. A church on Buesching Road near Illinois Route 22 was built in 1949. Francis Gudgeon and his son Jerry helped found the church. Jerry's wife, Leda, has remained active with the church. (Courtesy of St. Francis de Sales Catholic Church.)

Fr. Joseph Firnbach, who served as the first pastor at St. Francis, was known for devoting his life to the people of the church. He was named pastor emeritus in late 1969, and by early 1970, a retirement party was held in his honor in a gymnasium he helped build. He continued to live in the church's rectory, at least part-time, until he died in 1990. (Courtesy of Leda Gudgeon.)

Fr. John McEnroe served as St. Francis's second pastor until he died in 1982. Prior to McEnroe's arrival, the church had witnessed much growth. A school was added in 1956. The school's first graduating class in 1957 was made up of just eight students. Another church and gymnasium were constructed in 1968. (Courtesy of Leda Gudgeon.)

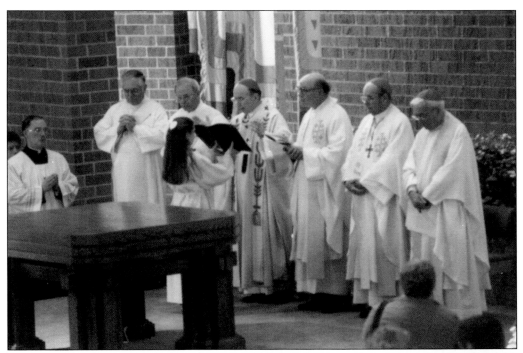

A construction boom in Lake Zurich in the 1980s brought with it an increase in membership at St. Francis. By 1986, a committee was formed to begin work on raising funds for a new church. Fr. Richard Valker, who served as St. Francis's third pastor (pictured third from right), attended the dedication mass for the new church in 1989, along with Joseph Cardinal Bernardin (pictured fourth from right). (Courtesy of Leda Gudgeon.)

Fr. Richard Valker served as an associate pastor before becoming the church's third pastor upon the death of Fr. John McEnroe in 1982. Valker was present for the ground-breaking ceremony for the new church in 1987. He served as pastor until 1992. (Courtesy of Leda Gudgeon.)

Fr. Ronald Gollatz was appointed St. Francis's fourth pastor in 1992. Over the years, St. Francis had grown from a church that could house roughly 250 people to one that could seat nearly 1,000 parishioners. By 2000, the membership of the church included 3,800 registered households. (Courtesy of Leda Gudgeon.)

This photograph shows the installation mass for Fr. David Ryan in the fall of 2006. In addition to the church constructed in 1989, other buildings on the property include the old church, which housed the library in its basement for a time, and a ministry center, which is located in the structure that was home to the Ela Public Library after it moved out of the church. (Courtesy of Leda Gudgeon.)

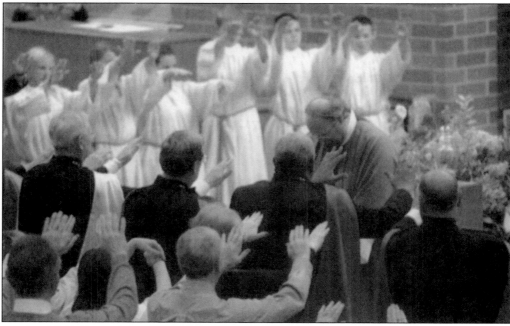

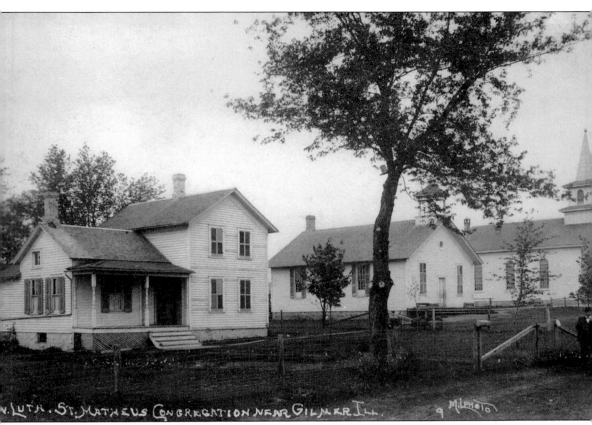

A congregation for St. Matthew Lutheran Church was organized in 1863, and a church, parsonage and cemetery were built in 1864 along Old McHenry Road. By 1889, the church built a one-room school. In 1893, the school's first teacher began instructing 53 students. By 1923, the church introduced services in English. They previously had been held in German. (Courtesy of St. Matthew Lutheran Church.)

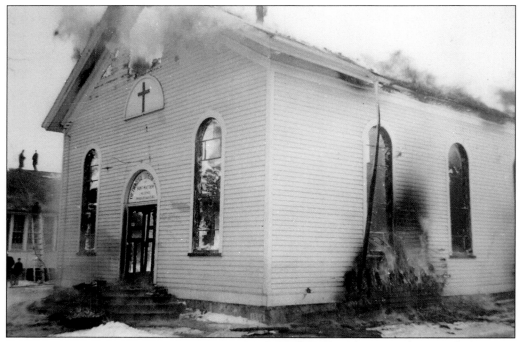

This 1942 photograph shows the fire that destroyed the church. A new church was not completed until 1949, as rebuilding was delayed due to a lack of materials during World War II. Services were held in the school auditorium for seven years. (Courtesy of St. Matthew Lutheran Church.)

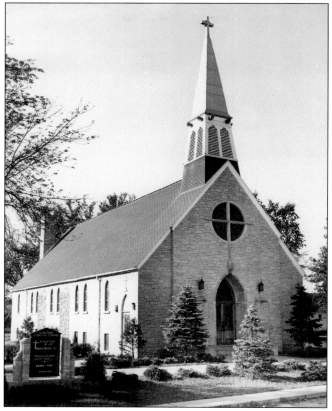

This photograph shows the church as it was rebuilt in 1949. A cornerstone was laid in the summer of 1948, and the service of dedication was held in June 1949. By the early 1950s, the congregation had grown to include about 300 members. (Courtesy of St. Matthew Lutheran Church.)

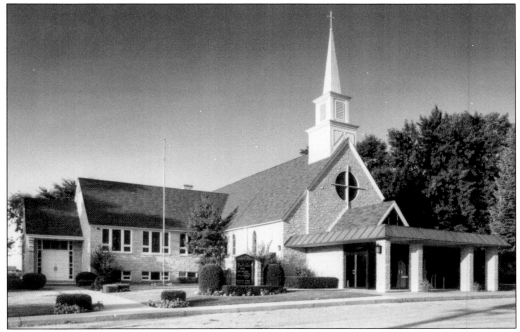

This c. 1960 photograph shows an addition to the church for which a cornerstone was laid in 1958. By 1959, periodic German services were discontinued. A new parsonage was constructed in 1960. A school was added in 1964, and a new church was completed in 1992. (Courtesy of St. Matthew Lutheran Church.)

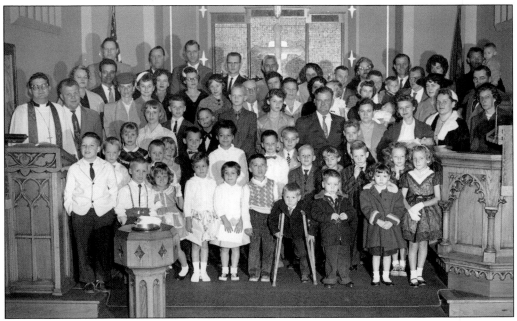

This 1959 photograph shows a mass baptism at St. Matthew's. Longtime pastor Rev. Harold Krueger is standing on the left. The church's congregation grew rapidly during the 1950s. A nursery was established to help out parents during worship time. (Courtesy of the Ela Historical Society.)

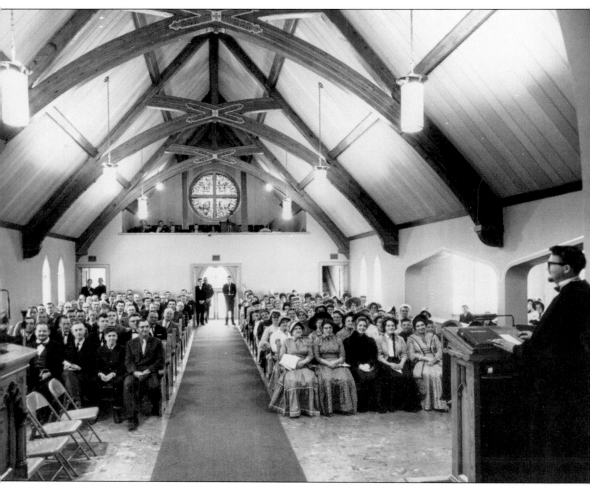

During the church's 100th anniversary in 1963, special services were held to re-create original rites held in 1863. This photograph shows parishioners dressed in period garb, recalling the church's early pioneer days. The congregation was asked to arrive by horse and buggy, instead of driving cars, for the special occasion. (Courtesy of St. Matthew Lutheran Church.)

Five

LAKE ZURICH SUMMERS

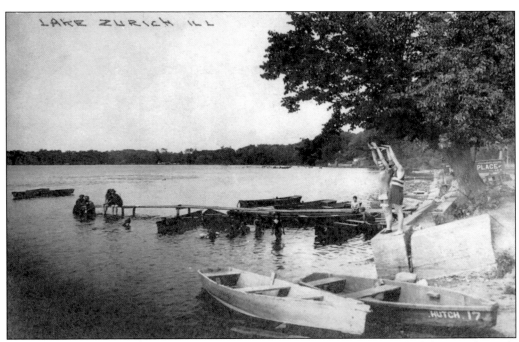

Summers in Lake Zurich have always marked some of the town's most fun-filled days. In the early 1900s, the lake drew summer tourists who stayed in local cottages, swam, and fished. But there was also plenty to do on dry land. People could go dancing, take in a theatrical performance, watch a parade, or attend a festival. No matter what visitors or locals chose to do, there was always something to explore during Lake Zurich summers. (Courtesy of Janet Paulus.)

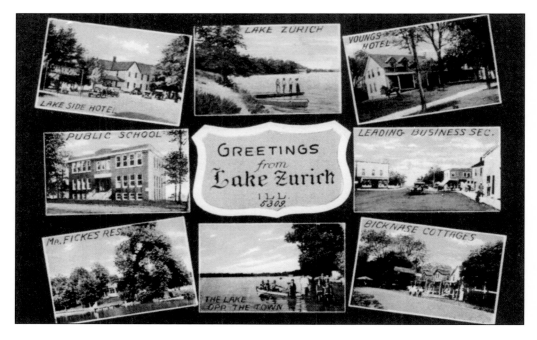

These two postcards allowed tourists to show folks back home just some of what Lake Zurich had to offer in the warm weather. The postcard above highlights some of the hotels, cottages, and boating fun to be had on the lake. The Lakeside Hotel, Young's Maple Leaf Hotel, and the Bicknase Cottages were among some of the places to stay in town. Below, picturesque scenes of families gathered on the lake's banks also provide a glimpse into those relaxed summer days of the past. (Above, courtesy of the Curt Teich Postcard Archives; below, courtesy of Janet Paulus.)

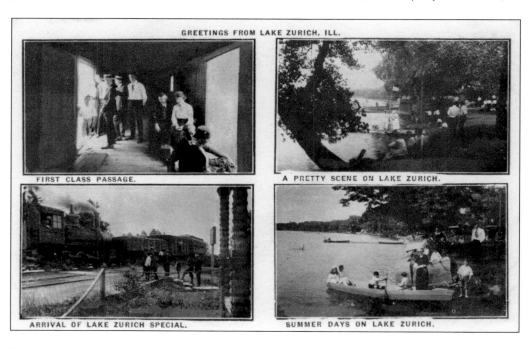

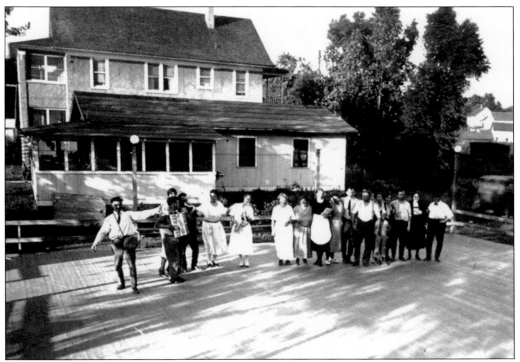

This photograph shows people stepping out on Fitzgerald's Dance Floor, which was located on Main Street near the lake. Dancing was just one of many pastimes people could enjoy in Lake Zurich if they wanted a break from swimming or boating. (Courtesy of the Ela Historical Society.)

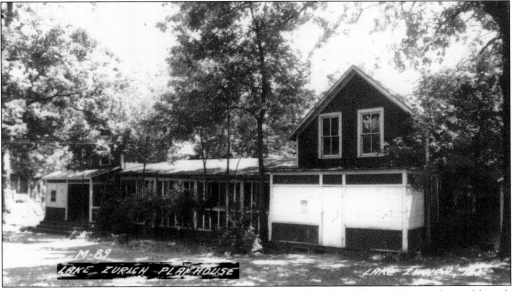

People also chose to take in shows while visiting Lake Zurich. About 200 people could pack into the Lake Zurich Playhouse to see performances during the summer months. Some students from Chicago's Goodman Theater, including Harvey Korman and Geraldine Page, appeared in productions at the playhouse after World War II. (Courtesy of the Ela Historical Society.)

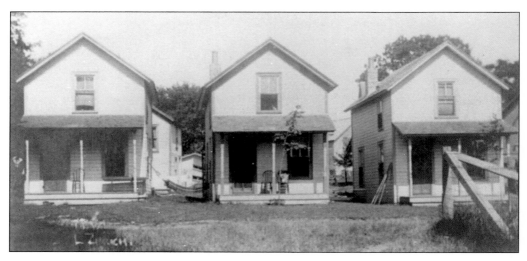

The cottages pictured above were originally operated by Herman Helfer and were one of the options where tourists could stay while visiting Lake Zurich in the early 1900s. The cottages were later operated by the Bicknase family before becoming part of the Farman Hotel property. Pictured below is another view of the cottages on Lakeview Place. Depending on whether people chose to stay in a cottage, hotel, or boardinghouse, rental rates ranged from 50¢ to $2 per day. Some places also offered swimming access and parking. Such locations were popular spots for women and their children, who vacationed by the lake during the summer months while their husbands continued working and visited mostly on the weekends. (Above, courtesy of the Ela Historical Society; below, courtesy of Janet Paulus.)

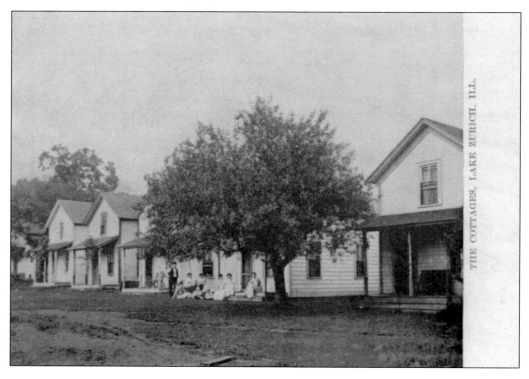

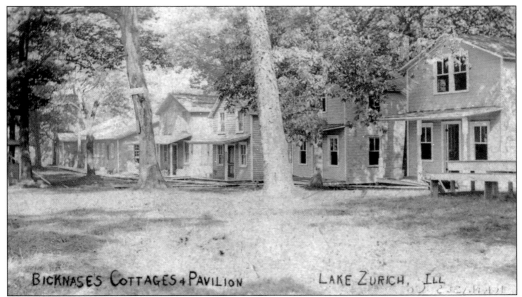

BICKNASES COTTAGES & PAVILION LAKE ZURICH, ILL

These photographs show views of the Bicknase Cottages on Lakeview Place and the transportation the family offered to its guests to travel back and forth from the train station. If tourists arrived at the cottages by horse and buggy, though, the Bicknases asked that they not tie their horses to the trees located on the property. In addition, William Bicknase, shown driving the automobile in the photograph below, ran the Lake Zurich Resort on Main Street. Also pictured in the photograph are Orval Bicknase, who is sitting on the radiator, and Myrtle Bicknase, who has her hand on the shoulder of Pearl Bicknase. (Above, courtesy of Janet Paulus; below, courtesy of the Ela Historical Society.)

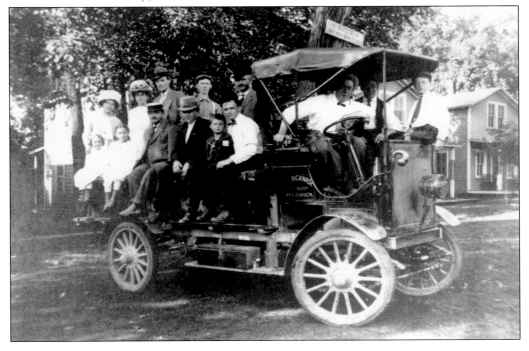

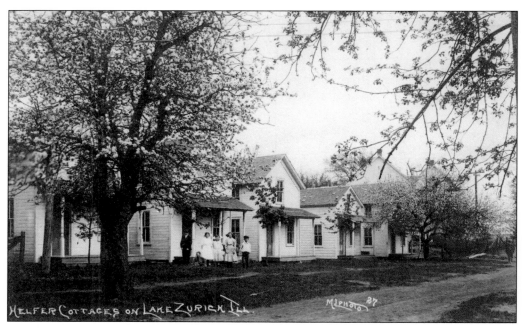

Herman Helfer also operated transportation, in the form of a horse and wagon, to bring guests to his Lakeside Hotel. Helfer's hotel later became the Farman Hotel. In addition, he offered cottages, which are pictured above, as accommodations. A fixture in Lake Zurich for years, the Farman Hotel, which featured a restaurant, was demolished. A residential housing development eventually was built on the property near the lake. Another place to stay was in one of the cottages on Oak Street, pictured below. No matter what their taste, visitors had their pick of places to stay in Lake Zurich. (Courtesy of Janet Paulus.)

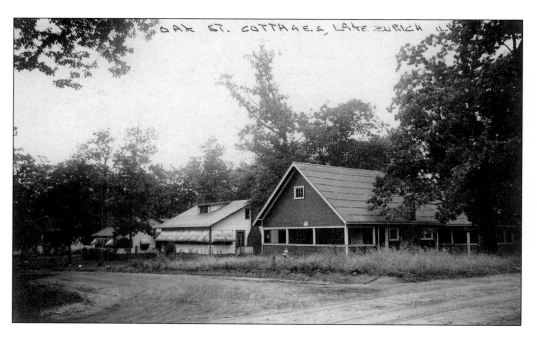

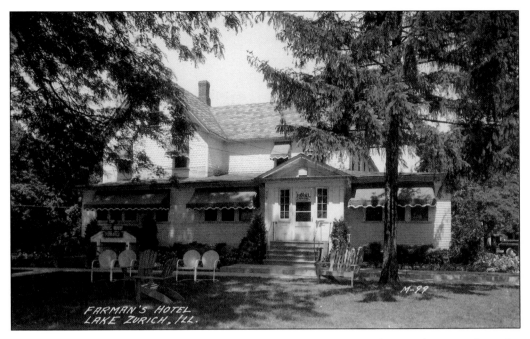

The Farman Hotel served visitors from all walks of life in its day. Jockeys and trainers from the Arlington Park racetrack in nearby Arlington Heights often came to stay at the hotel. Legendary WGN radio announcer Franklyn MacCormack was known to eat at the hotel's restaurant. Getting its start as a farmhouse, Herman Helfer ran the place as the Lakeside Hotel in the early 1900s. Guy Farman took over the business in 1929. Nearly three dozen staff members worked at the hotel by 1965. Charles Ladd worked as chef at the hotel for nearly 30 years while his wife, Isabel, worked as head waitress for 17 years. (Courtesy of Janet Paulus.)

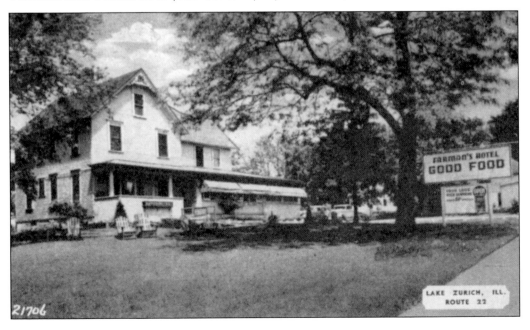

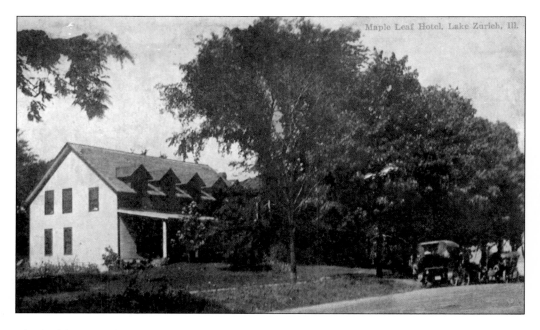

The building that housed Young's Maple Leaf Hotel was originally built as a gathering place by Seth Paine in the 1840s. It later served as the town's first school and church. During the Civil War, the building became part of the Underground Railroad. By 1907, Philip Young bought the property and turned it into a hotel. His son Edward Young took over the business in 1930. In 1957, the Young family sold the land, and the hotel was torn down, making way for a gas station. The postcard below features Young's Maple Leaf Hotel as one of Lake Zurich's attractions. (Courtesy of Janet Paulus.)

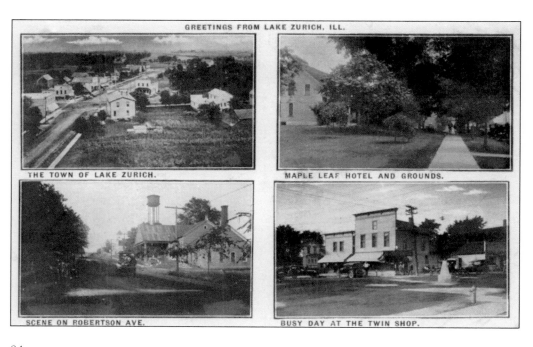

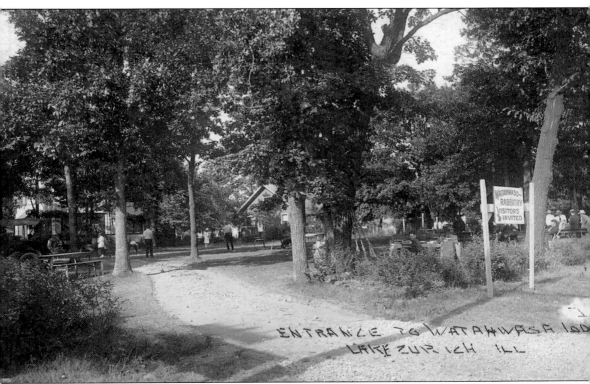

The Watahwasa Lodge was located on the north side of Lake Zurich. The property featured seven cottages, and space could be rented on the grounds for parking. Boat rentals were also available. For two years, the lodge was operated by Roy and Josephine Loomis. (Courtesy of Janet Paulus.)

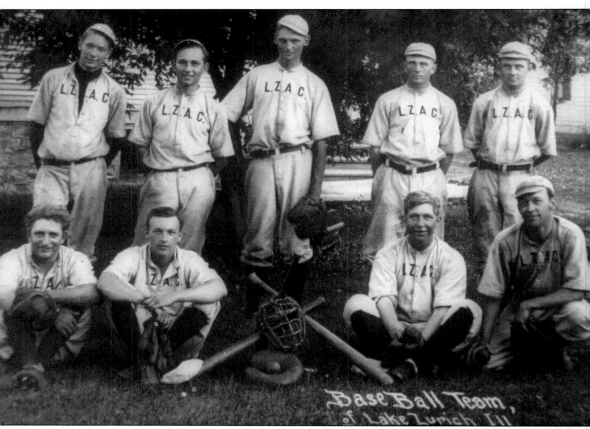

It was not just the tourists who loved summers in Lake Zurich. The locals enjoyed them just as much. This c. 1912 photograph shows a town baseball team. From left to right are (first row) Richard Eichmann, Russ Blankenburg, Ed Mavis, and Wallie Parker (a ringer sent in from Chicago); (second row) Phil Schaeffer, Albert Prehm, Charles Meyer, Emmet Branding, and Ed Branding. (Courtesy of the Ela Historical Society.)

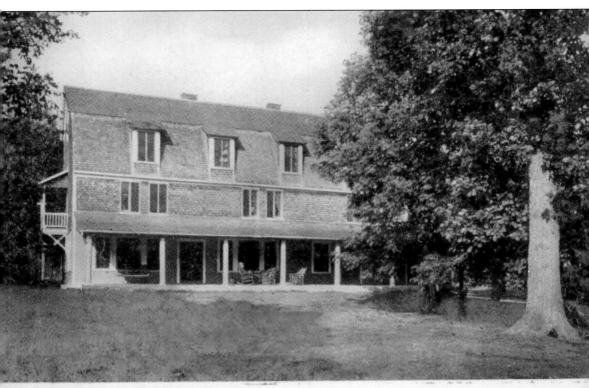

GOLF CLUB HOUSE, LAKE ZURICH, ILL. 5308.

Another summer pastime was golf. The clubhouse at the Lake Zurich Golf Course was built in 1896. The three-story building featured a kitchen and dining room on the first floor, bedrooms on the second floor, and a dormitory on the third floor. Founded in 1895, the golf club exclusively served men until 1946, when women and children were allowed on the property. (Courtesy of Janet Paulus.)

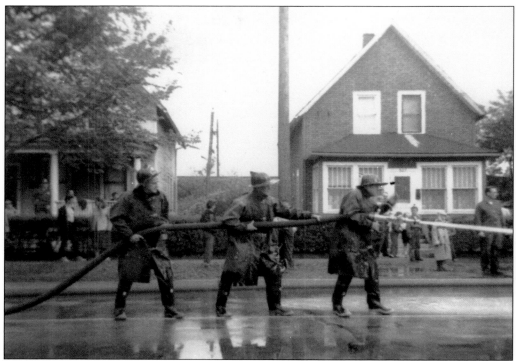

Firefighter water fights also served as a form of summer entertainment. The 1957 photograph above shows, from left to right, LeRoy Grever, Bill Hapke, and Norman Schuldt holding the hose. Below, Howard Branding is shown controlling the hose during another water fight. Teams from the Lake Zurich Fire Department would participate in similar events throughout nearby communities during the summer months. Lake Zurich's volunteer fire department was officially organized in 1933. William Buhr was chosen as the first chief. Other early members of the department included Ira Ernst, Julius Geary, and Albert Heybeck. (Courtesy of the Ela Historical Society.)

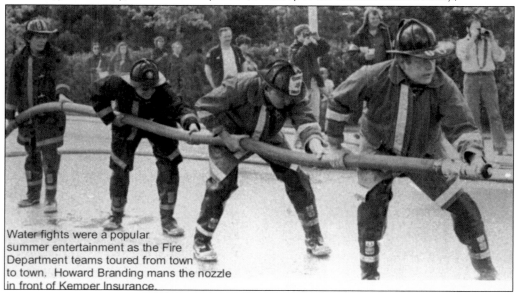

Water fights were a popular summer entertainment as the Fire Department teams toured from town to town. Howard Branding mans the nozzle in front of Kemper Insurance.

What would summer be without a good parade? George Lantz, a longtime school band leader, is shown in this photograph taken along Main Street during a Memorial Day parade in 1955. Lantz taught countless students in the community how to play their instruments. (Courtesy of the Ela Historical Society.)

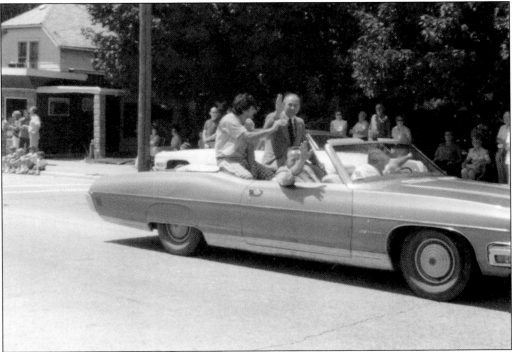

Mayor Henry "Hank" Paulus waved to the crowd while sitting on top of a convertible during a summertime Alpine Fest parade in the mid-1970s. During his years as a local public official, Paulus participated in countless parades and community events. (Courtesy of Henry "Hank" Paulus.)

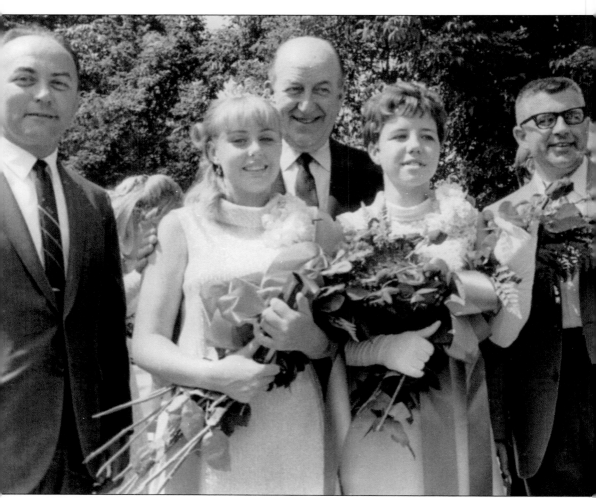

It just wouldn't be summer in Lake Zurich without Alpine Fest, which the Lions Club began in 1945. Held every July, the festival attracts thousands of people over three days. This early 1970s photograph shows the Alpine queens with, from left to right, Mayor Henry "Hank" Paulus, WGN radio announcer Franklyn MacCormack, and Bob Bauer. Whoever sold the most tickets was awarded queen status. (Courtesy of Henry "Hank" Paulus.)

Six

GROWTH AND DEVELOPMENT

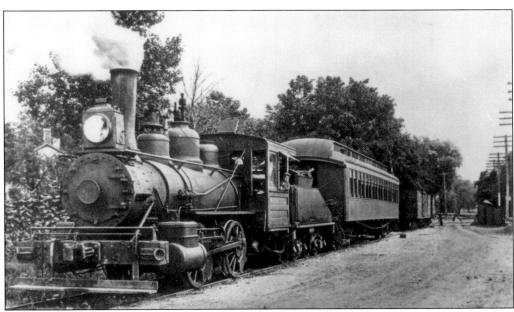

Lake Zurich has gone through various phases of growth and development since its beginnings. One of the early signs of growth was the dawn of the Palatine, Lake Zurich, and Wauconda Railroad. *Old Maud*, one of the engines of the PLZ&W, is pictured in this postcard in 1912. The desire to bring a line to Lake Zurich grew, along with the number of summer visitors who were in search of an easier way to travel. (Courtesy of the Ela Historical Society.)

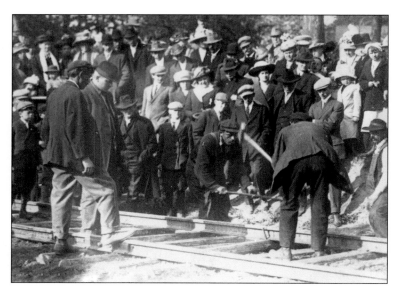

This 1912 photograph shows the last spike being driven into the PLZ&W railroad track. Trains initially only operated on the weekends. And while the summer months proved popular for train travel, the railroad did not succeed in the end, as automobiles became more prevalent. (Courtesy of the Ela Historical Society.)

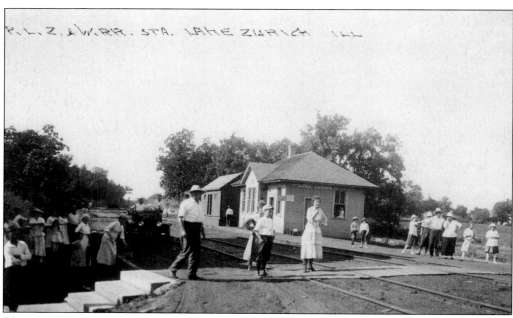

The PLZ&W station was constructed on Lions Drive, which was known as Railroad Street in the early 1900s. By 1924, the railroad could no longer make ends meet, and service was suspended. The Lions Club, which bought land from the defunct railroad, built Fred Blau Park on some of the property and donated another part to the village to construct Lions Drive. (Courtesy of the Ela Historical Society.)

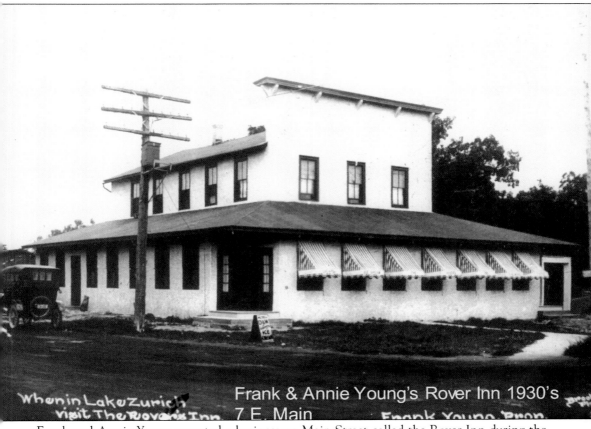

Frank and Annie Young operated a business on Main Street called the Rover Inn during the 1930s. The Rover Inn was known as a popular restaurant in town, with good food and dancing. (Courtesy of the Ela Historical Society.)

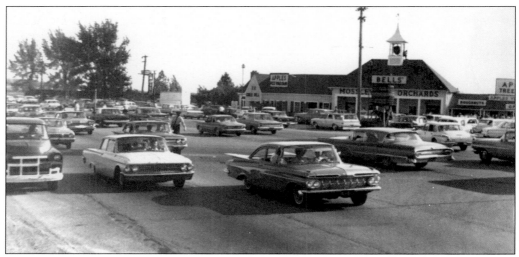

Bell's Apple Orchard was long known as a place for residents and visitors to pick apples and sip fresh cider. The business near US Route 12 and Illinois Route 22 started out in the 1930s between John Bell and William Webbe. By the late 1980s, part of the property was used to make way for homes in a subdivision appropriately named The Orchards. (Courtesy of the Historical Society.)

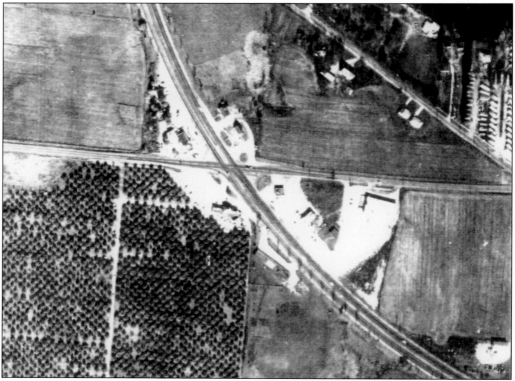

Bell's Apple Orchard can be seen in this 1960s aerial photograph. In those days, the borders of the orchard came very close to the intersection of US Route 12 and Illinois Route 22. While farmland is present in this photograph, the area rapidly developed. A Target store and the Dominick's and Jewel grocery stores were eventually built nearby. (Courtesy of the Ela Historical Society.)

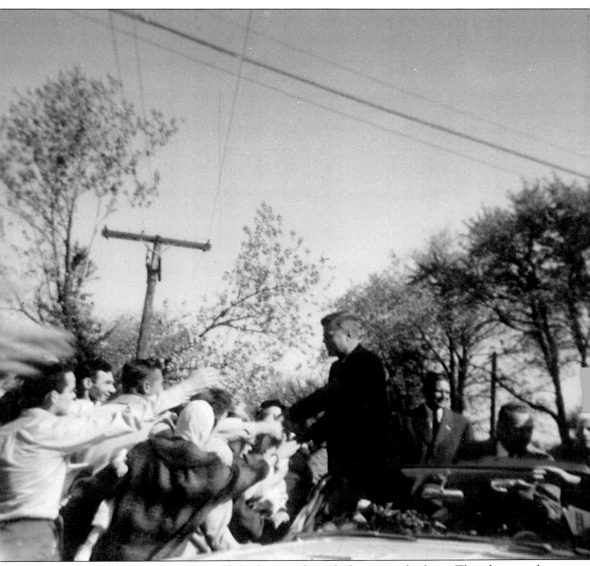

Signs of growth in Lake Zurich could also be seen through the scope of politics. This photograph shows presidential candidate John F. Kennedy on the campaign trail in Lake Zurich. Illinois governor Otto Kerner and Illinois senator Everett Dirksen accompanied Kennedy. (Courtesy of the Ela Historical Society.)

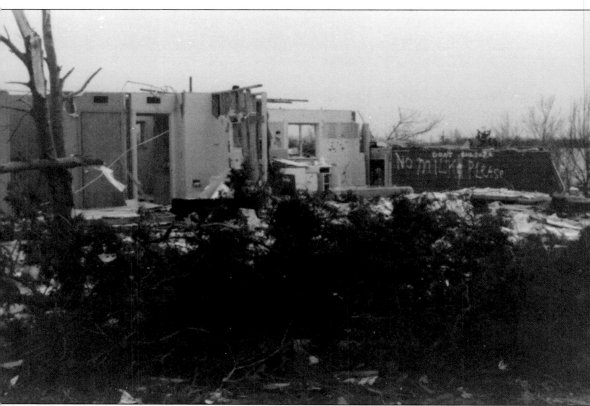

With growth comes setbacks. In the spring of 1967, Lake Zurich was hit by a tornado that destroyed Seth Paine Elementary School and dozens of nearby homes. While some people were injured, there were no fatalities, and the school and homes were rebuilt. (Courtesy of the Ela Historical Society.)

This 1971 photograph shows a friend, Eddie Backman, giving David and Karin Lindgren the keys to their new home in a Lake Zurich subdivision called Old Mill Grove. The couple had been living in Chicago when a friend suggested they look at model homes in the community. They liked what they saw and ended up living there for more than 30 years. (Courtesy of the Lindgren family.)

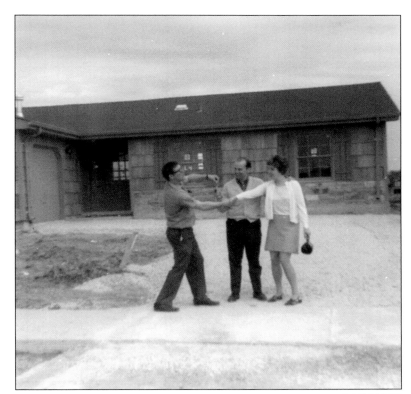

The Lindgrens bought their three-bedroom, two-bathroom ranch home in 1971 for $28,990. The family recalled that their first year's taxes on the property were $101. The couple went on to have one child, Kristina, who was born in 1974 and grew up in the home. (Courtesy of the Lindgren family.)

While trees matured and fences went up over the years in Old Mill Grove, there were open backyards and little vegetation when the Lindgren family moved in. No fences and just one young tree are visible in the background as David and Karin Lindgren pose on their property. (Courtesy of the Lindgren family.)

Karin Lindgren bends down in the driveway in front of her new home to pet Flicka. The couple's front yard was also void of much greenery when they moved in. Over the years, bushes were planted around the home, and mature trees began to line the neighborhood's streets. (Courtesy of the Lindgren family.)

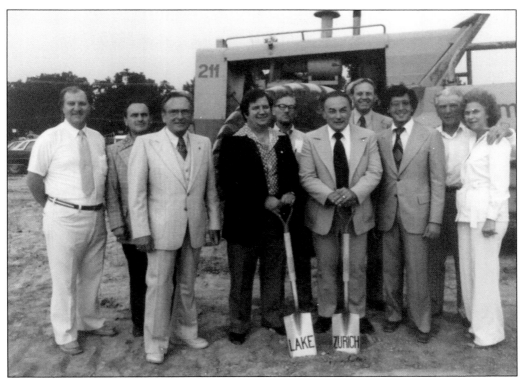

Several big businesses started cropping up in Lake Zurich in the late 1970s. Pictured above is the ground-breaking for the Kmart building along US Route 12. Some of the people in attendance included trustee Lowell Dobbins (holding shovel on the left) and Mayor Henry "Hank" Paulus (also holding shovel). The store opened in 1981 but eventually went out of business at that location in 2002. Another company that opened was the Jewel-Osco store on Ela Road, bringing closer grocery shopping to the community. Pictured below is the Jewel-Osco ground-breaking event. (Courtesy of Henry "Hank" Paulus.)

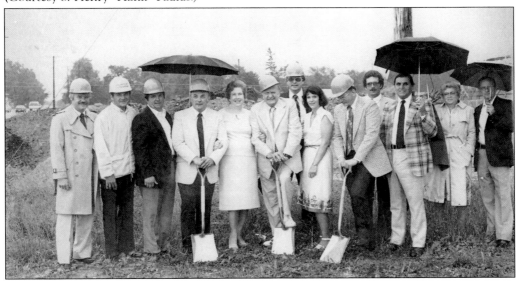

This photograph shows the site of a commercial retail development called the Town Mall, which was planned between Buesching and Old Rand Roads. Foundations were poured and some electrical work was done, but financing was not secured, and the development never moved forward. The location eventually became home to such buildings as the post office, a bank, and the Ela Area Public Library. (Courtesy of Henry "Hank" Paulus.)

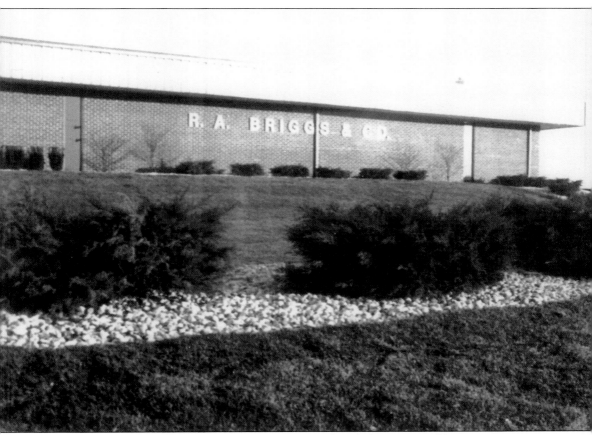

The R.A. Briggs custom textile printing company was founded in 1940 and began operating in Lake Zurich in 1953 with about two dozen employees. The original factory was located along Old Rand Road, but in 1969, the growing company of more than 100 employees moved to Midlothian Road near Lake Zurich High School. (Courtesy of the Ela Historical Society.)

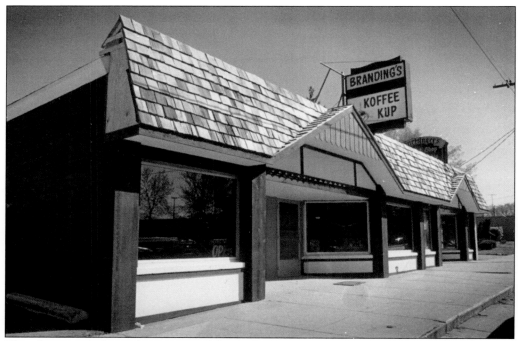

This photograph shows the exterior of the Koffee Kup restaurant, which was owned by Howard and Karen Branding and opened in 1969. The business has been a fixture on Main Street for years. (Courtesy of Howard and Karen Branding.)

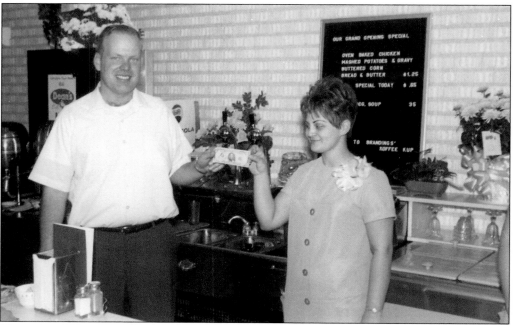

Howard and Karen Branding proudly display the first dollar they earned on the Koffee Kup's opening day. They kept the business until the mid-1970s, when they sold it and bought the floristry. (Courtesy of Howard and Karen Branding.)

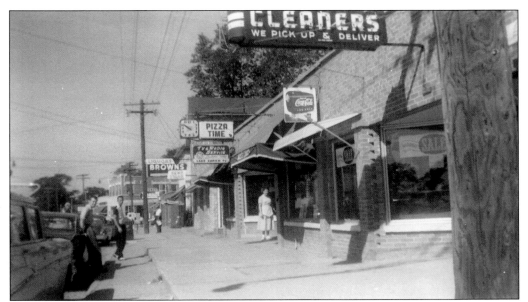

This c. 1958 photograph shows the myriad businesses that occupied spots along Main Street at the time, including a pizza shop, a cleaners, and a liquor store. (Courtesy of Howard and Karen Branding.)

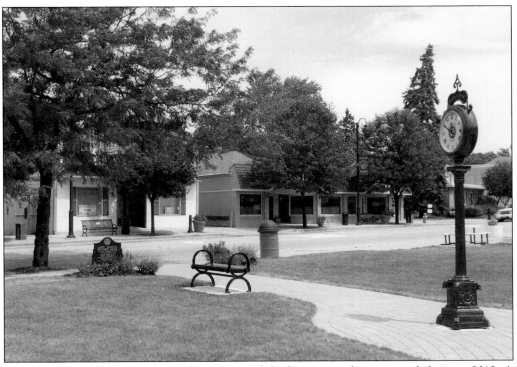

This photograph of Main Street shows some of the businesses that operated there in 2010. A small Lake Zurich Rotary Club park occupies the property at the corner of Main Street and Old Rand Road where a gas station once was. (Photograph by Michael Flynn.)

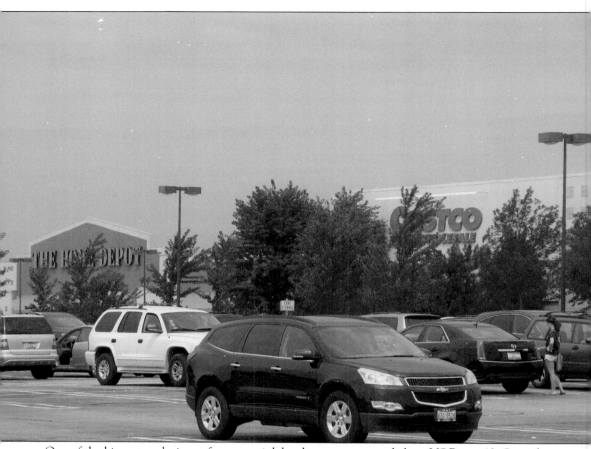

One of the biggest explosions of commercial development occurred along US Route 12. Countless businesses—including major retailers like Home Depot, Costco, and Starbucks—occupy space along the busy strip. A movie theater also was built in this location. (Photograph by Michael Flynn.)

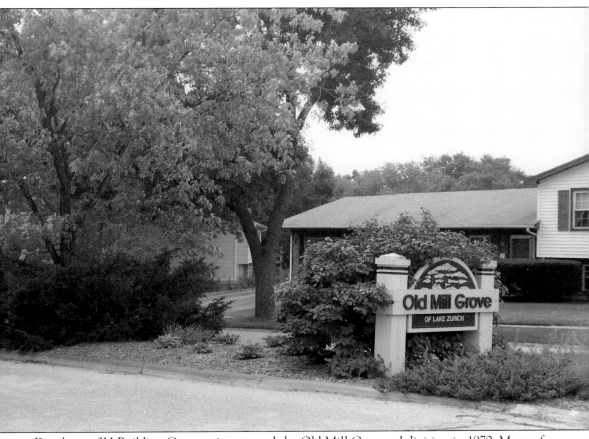

Developers 3H Building Corporation erected the Old Mill Grove subdivision in 1970. Many of the homes at the time (10 models were offered) sold for less than $30,000. Styles ranged from ranch to tri-level and featured three to five bedrooms. Countless families continue to call the subdivision home. (Photograph by Michael Flynn.)

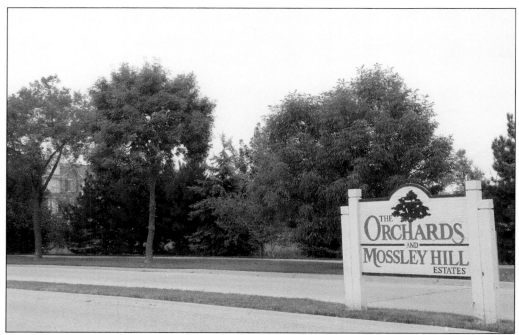

The Orchards and Mossley Hill Estates subdivision near Illinois Route 22 and US Route 12 was built on property once occupied by Bell's Apple Orchard. John Bell, who owned the apple trees, and William Webbe, who owned the land, originally sold apples from a stand near the orchard, which spanned roughly 100 acres. Various members of the Bell family continued to operate the business over the years before the property was subdivided to make way for houses. Homes in the Mossley Hill Estates part of the subdivision can be seen in the photograph below, overlooking a pond. (Photographs by Michael Flynn.)

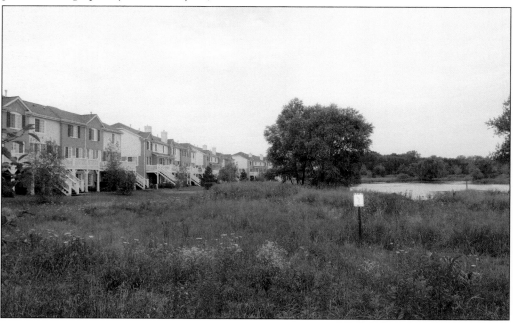

Seven

LAKE ZURICH TODAY

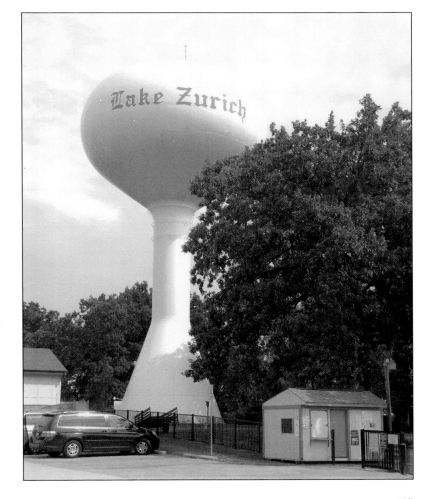

Although much has changed in Lake Zurich throughout the years, some parts of town, such as the lake and parks, remain peaceful places where visitors and families continue to spend their recreation time. This photograph shows a view of the Lake Zurich water tower at Paulus Park along US Route 12. (Photograph by Michael Flynn.)

But parts of the lake have undoubtedly changed over time. For instance, the days of the old concrete seawall and, later, the steel structure along a portion of Lake Zurich are long gone. A new promenade, dedicated in 2003, includes black, wrought-iron fencing along the lake's banks. Matching lighting, benches, a winding brick pathway, and banners welcoming people to Lake Zurich were also added at the site. Across the street from the seawall was J.J. Twig's Pizza and Pub, which had been a local fixture for 20 years. The restaurant, which was well known for allowing patrons to toss peanut shells on the floor, burned down in 2004. (Photographs by Michael Flynn.)

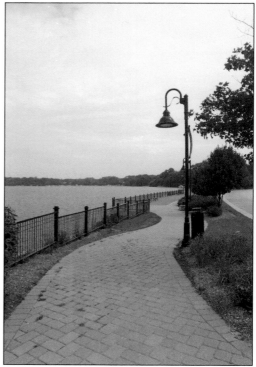

Other locations on the lake look much as they did in the past. Bill's Boats is just steps down the road from the new promenade area. These two photographs taken near the business are reminiscent of a bygone era, showing vistas of the lake beyond a stone wall dotted by flower pots. These views make it possible to forget, if just for a moment, about all of the development that has occurred surrounding the lake. (Photographs by Michael Flynn.)

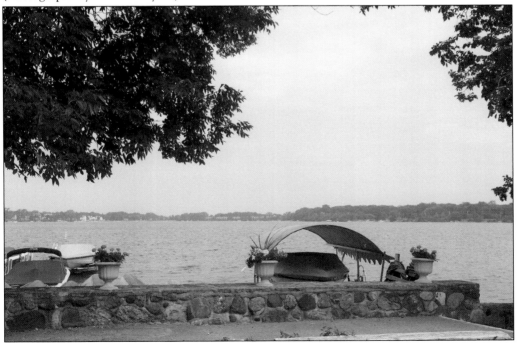

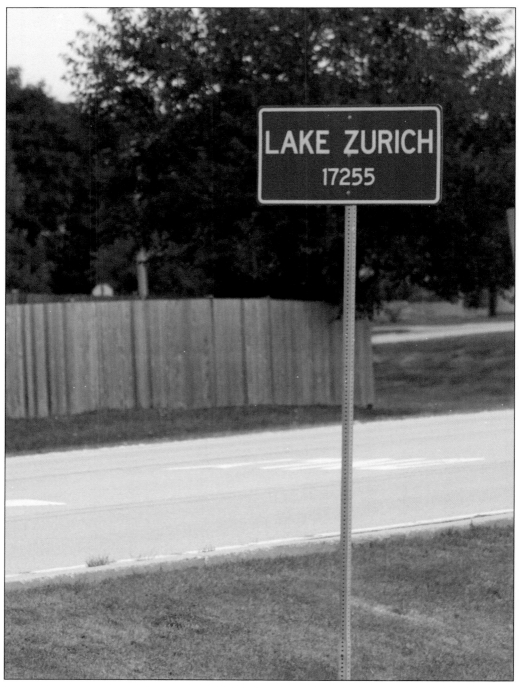

This photograph of a population sign in town shows just how much has changed over the years in terms of the people living here. Despite the number on the marker, Lake Zurich's population is estimated to be more than 19,000. Many longtime residents have stayed in Lake Zurich for decades, while countless young couples with children have decided to move to the area for its quality of life and education. (Photograph by Michael Flynn.)

This photograph shows three generations of the Branding family, all of whom continue to call Lake Zurich home. Howard and Karen Branding posed in front of their house with their daughter, Amy Branding Matheson; her husband, Sean Matheson; and the Matheson's three daughters, Morgan, Ava, and Rylee. (Photograph by Michael Flynn.)

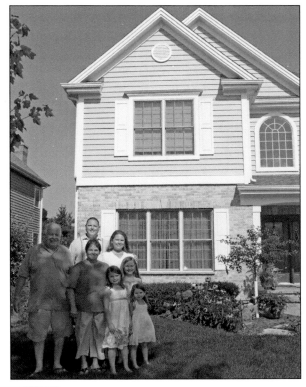

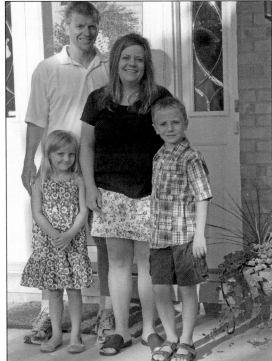

Chris Keller and his wife, Becky (Schneider) Keller, pose on the front steps of their Lake Zurich home with their two children, Vanessa and Josh. Chris Keller moved to Lake Zurich as a toddler, and Becky (Schneider) Keller moved to town as a teenager. Both of their children have shared the same kindergarten classroom at Seth Paine Elementary School as Chris Keller did when he was a boy. (Photograph by Michael Flynn.)

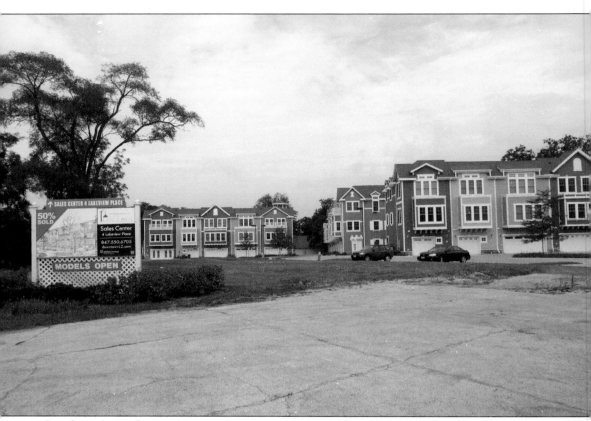

Residential townhouses now stand on the site of the old Farman Hotel. The ground-breaking for the development near Lakeview Place happened in 2006. A group of old cottages by the lake were demolished in 2005 to make room for the townhouses. (Photograph by Michael Flynn.)

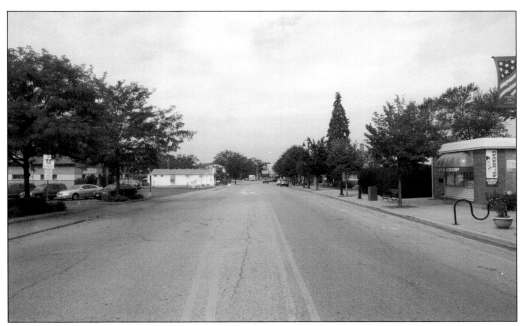

This photograph shows a view of downtown Lake Zurich looking west on Main Street toward a townhouse development. Don's Barber Shop, a fixture in the village for years, can be seen on the right. Businesses, such as the floristry and the Koffee Kup, are located just up the road from the barbershop. (Photograph by Michael Flynn.)

The Lake Zurich Village Hall was moved to its location on Main Street in the late 1980s. The building previously was home to the old Great Lakes Savings and Loan bank. The village hall used to be located on Main Street closer to the lake. (Photograph by Michael Flynn.)

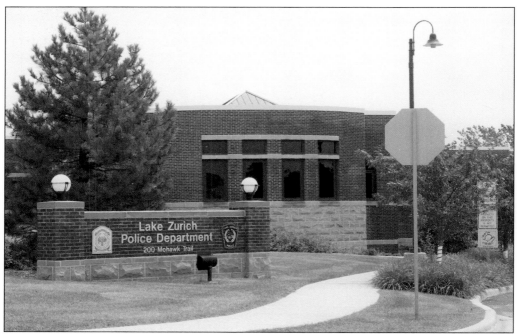

These photographs show the Lake Zurich Police Department and one of the town's four fire stations. The police department, which has 34 sworn officers, moved to its location on Mohawk Trail in 2002. The department handles about 10,000 calls for service each year. The Lake Zurich Fire Department is made up of 54 staff members and averages more than 3,000 service calls a year. It also features a civilian fire prevention bureau made up of four people. In addition to protecting Lake Zurich, the department provides service for the Lake Zurich Rural Fire Protection District, which includes parts of Hawthorn Woods, North Barrington, and Kildeer. (Photographs by Michael Flynn.)

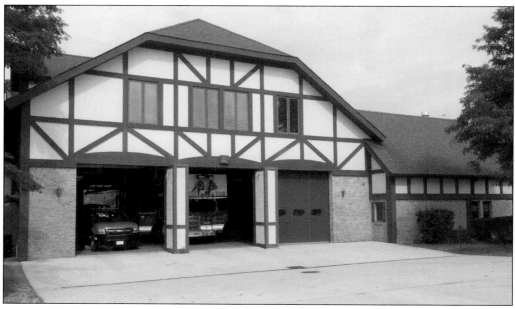

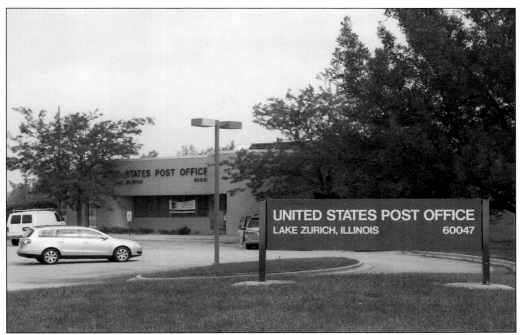

Shown in these photographs are Lake Zurich's post office on Surryse Road and the Ela Area Public Library building on Mohawk Trail, where it has been located since 2002. The library operated out of the basement of St. Francis de Sales Catholic Church from 1972 to 1982. Its books were initially maintained by the Lake Zurich Woman's Club. By the early 1980s, construction had begun on a new building along Buesching Road, where the library was located for about two decades. In the late 1990s, plans were underway to construct the library's current building. (Photographs by Michael Flynn.)

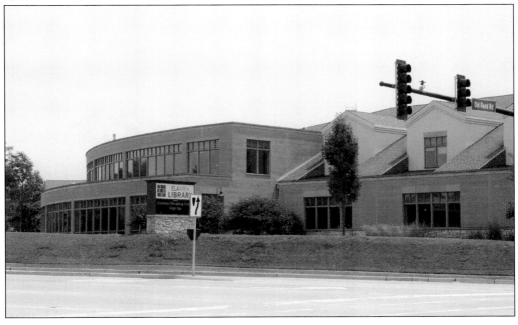

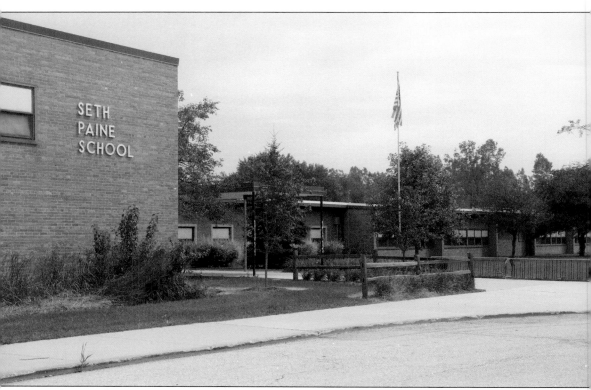

Lake Zurich Community Unit School District 95 is made up of five elementary schools, two middle schools, and one high school. This photograph shows Seth Paine Elementary School, which was rebuilt on Miller Road after being destroyed by the 1967 tornado that hit Lake Zurich. (Photograph by Michael Flynn.)

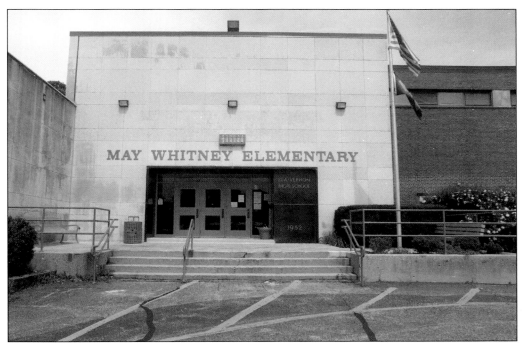

May Whitney and Sarah Adams, who were some of Lake Zurich's earliest teachers, also have elementary schools named after them. The school district serves children from Lake Zurich, Kildeer, Hawthorn Woods, Deer Park, North Barrington, and unincorporated Lake County. Sarah Adams Elementary School is located within the Old Mill Grove subdivision. May Whitney Elementary School operates out of the old Ela Vernon High School building along Church Street. The school had been located in a neighboring location until mold and asbestos were discovered in 2007, prompting the school's closure. (Photographs by Michael Flynn.)

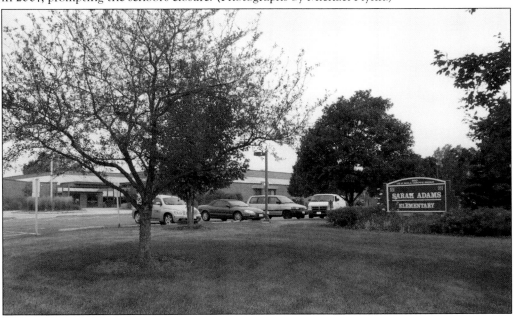

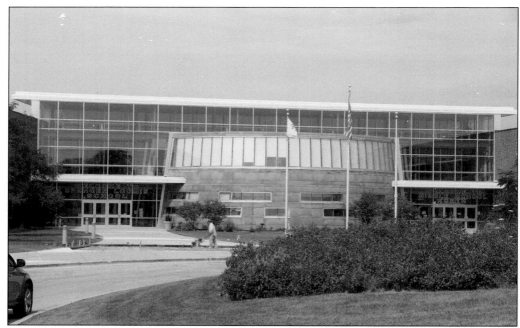

A school campus, shown above, on Hubbard Lane in Hawthorn Woods is home to Spencer Loomis Elementary School and Middle School North. The elementary school was named after Spencer Loomis, a longtime teacher and principal at May Whitney Elementary School. Pictured below is another campus on Cuba Road in Lake Zurich where Isaac Fox Elementary School and Middle School South are located. Isaac Fox donated the land on which the Ela Town Hall was built. He donated it for use as a school and other public purposes. (Photographs by Michael Flynn.)

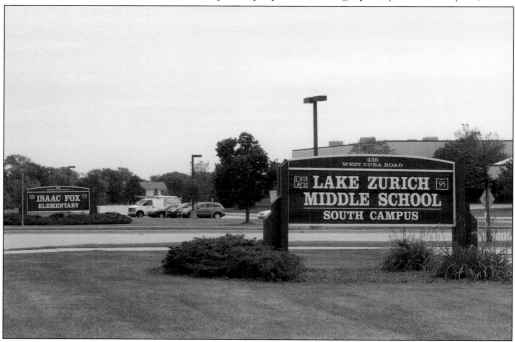

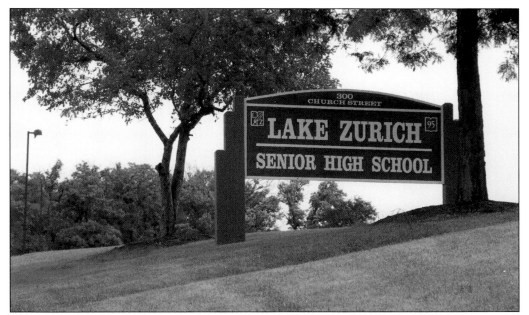

These photographs show views of the campus where Lake Zurich High School is located along Church Street. Known for its athletic mascot, the bear, the high school features a student newspaper, the *Bear Facts*, and a myriad of clubs and organizations in addition to its regular education program. More than 2,000 students attend the high school, which has more than 150 staff members. The district enrolls more than 6,000 students among all of its schools. It is overseen by the Board of Education, which is comprised of seven members of the community. (Photographs by Michael Flynn.)

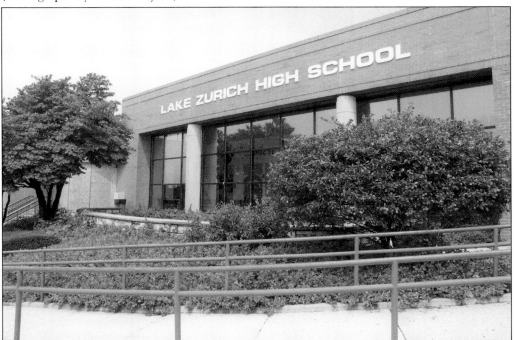

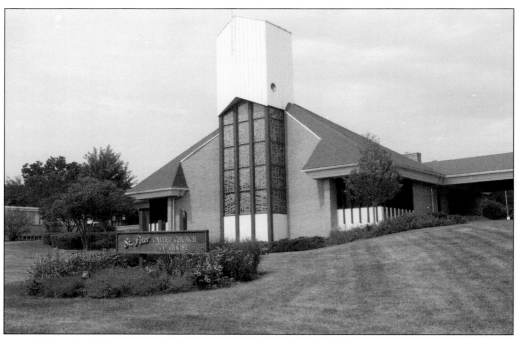

St. Peter United Church of Christ continues to serve about 450 members in the Lake Zurich area. Unlike the old days when the church was the solitary institution on top of the hill along Church Street, the road is now lined by several schools and homes. (Photograph by Michael Flynn.)

St. Matthew Lutheran Church along Old McHenry Road in Hawthorn Woods has more than 2,000 members, many of whom live in the Lake Zurich area. Some of the buildings on the 14-acre campus include the main church that seats 600 people, a chapel built in 1949, and school facilities with nearly a dozen classrooms. (Photograph by Michael Flynn.)

These two photographs show views of St. Francis de Sales Catholic Church. Above is the new church, which was dedicated in 1989, and below is the original 1949 church, which housed the Ela Area Public Library's collection in its basement for about a decade beginning in the early 1970s. Interestingly, the church also now has a ministry center that operates out of the building that was home to the Ela Public Library after it moved out of the basement. The congregation at St. Francis has roughly 4,200 registered families. (Photographs by Michael Flynn.)

After years in the making, a four-lane bypass around downtown Lake Zurich was completed in 2006. The bypass was designed to alleviate traffic congestion, reconfiguring the roads to change the way motorists traveled around town. The photograph above shows a view of Illinois Route 22 looking west with a sign pointing right toward downtown Lake Zurich as the bypass curves toward the left. The photograph below shows another view of Illinois Route 22 at the intersection with Main Street. Cars and trucks can be seen traveling under the Elgin, Joliet, and Eastern Railroad tracks. (Photographs by Michael Flynn.)

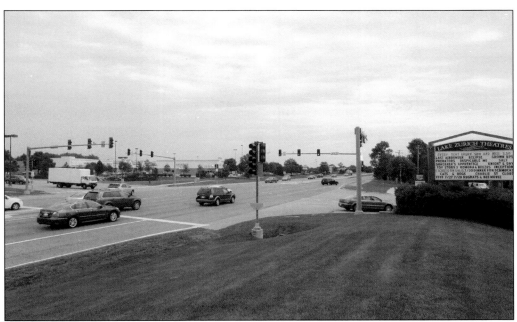

US Route 12 has been one of the locations in Lake Zurich where commercial growth has exploded over the years. The photograph above shows a busy intersection along the roadway that has become home to a movie theater, restaurants, and other retail shopping. The image below shows a nearby strip mall where various shops, including a Walmart and Goodwill store, are located. Just up the road from these sites is more commercial development, such as grocery stores and fast food restaurants. Despite the growth along this corridor, open space still exists in the form of places like Paulus Park near the lake. (Photographs by Michael Flynn.)

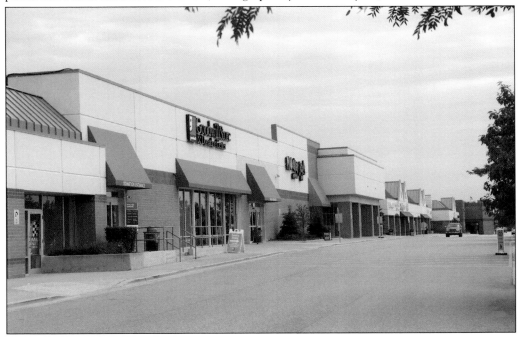

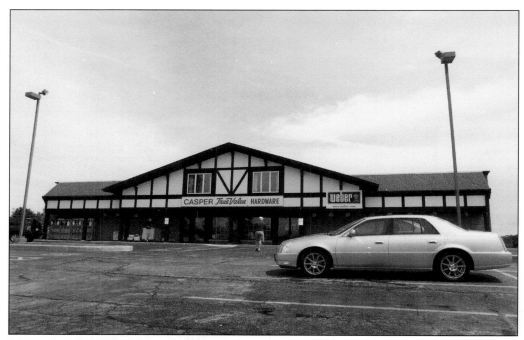

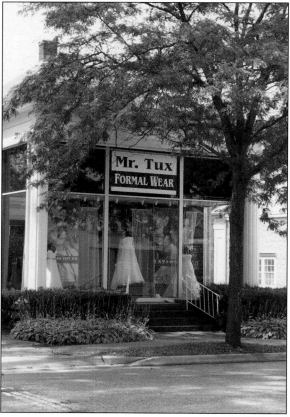

Closer to downtown, some local businesses that have been around for years continue to operate. The photograph above shows the Casper True Value Hardware store along Old Rand Road. The hardware shop, which the Casper family bought in 1966, originally was located at the intersection of Old Rand Road and Main Street. That location was where Carl Ernst ran his department store in the early 1900s. The photograph at left shows the location of Volle's Bridal and Boutique and Mr. Tux Formal Wear, which is just up the street from the hardware store. The businesses have serviced brides and grooms for decades. (Photographs by Michael Flynn.)

While its days as a summer resort destination have passed, summers in Lake Zurich continue to be a time of fun and excitement for residents and visitors. Alpine Fest still draws thousands of people over the three days it is held each July. The event features carnival rides, food, and entertainment. It also includes a parade through town. Sponsored by the Lions Club, Alpine Fest is held at Fred Blau Park along Main Street. The festival has grown considerably since its start in 1945 after the Lions acquired the land for the park. (Photographs by Michael Flynn.)

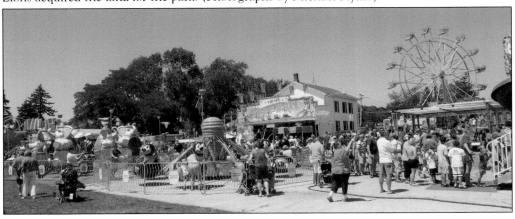

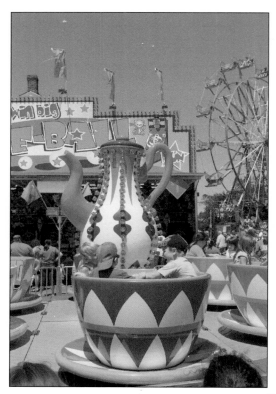

One of the main groups of people to enjoy the festival has been the children. Countless young families have moved into Lake Zurich over the years, and events such as Alpine Fest have quickly grown to become favorite activities that the kids look forward to each year. These photographs show children at the 2010 event smiling on the teacup ride and the giant slide. While many longtime community members continue to reside in Lake Zurich, the village's schools and family atmosphere, in part, have drawn newer residents. (Photographs by Michael Flynn.)

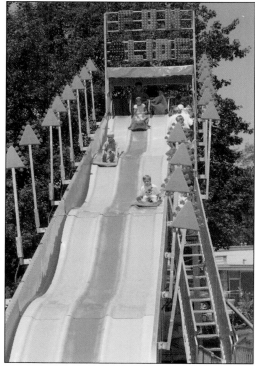

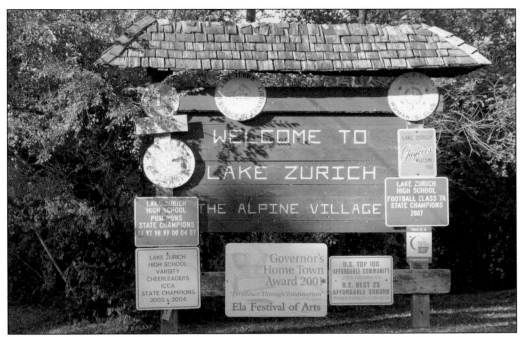

As Lake Zurich continues to grow and develop, the village will be sure to hold onto its greatest assets: the people who live there, the organizations and businesses that help it thrive, and the lake. Always at the heart of town has been the lake. (Photograph by Michael Flynn.)

BIBLIOGRAPHY

Dretske, Diana. *Lake County, Illinois: An Illustrated History*. London, Canada: Sun Fung Museum Catalogs & Books, 2007.

Haines, Elijah. *The Past and Present of Lake County, Illinois*. Chicago, IL: Wm. LeBaron & Company, 1877.

Halsey, John J. *A History of Lake County, Illinois*. Roy S. Bates, 1912.

Loomis, Spencer. *A Pictorial History of Ela Township*. Walsworth Publishing Company.

———, and Gloria Heramb. *Lake Zurich Centennial, One Hundred Years of a Midwestern Village*. 1996.

Village of Lake Zurich. *Jubilee, 75th Anniversary Celebration*. 1971.

Whitney, Richard. *Old Maud: The Story of the Palatine, Lake Zurich & Wauconda Railroad*. Polo, IL: Transportation Trails, 1992.

DISCOVER THOUSANDS OF LOCAL HISTORY BOOKS
FEATURING MILLIONS OF VINTAGE IMAGES

Arcadia Publishing, the leading local history publisher in the United States, is committed to making history accessible and meaningful through publishing books that celebrate and preserve the heritage of America's people and places.

Find more books like this at
www.arcadiapublishing.com

Search for your hometown history, your old stomping grounds, and even your favorite sports team.

Consistent with our mission to preserve history on a local level, this book was printed in South Carolina on American-made paper and manufactured entirely in the United States. Products carrying the accredited Forest Stewardship Council (FSC) label are printed on 100 percent FSC-certified paper.

MADE IN THE